BEGINNER'S GUIDE TO DRAWING

MANGA
CHIBI GIRLS

Create Your Own Adorable Mini Characters

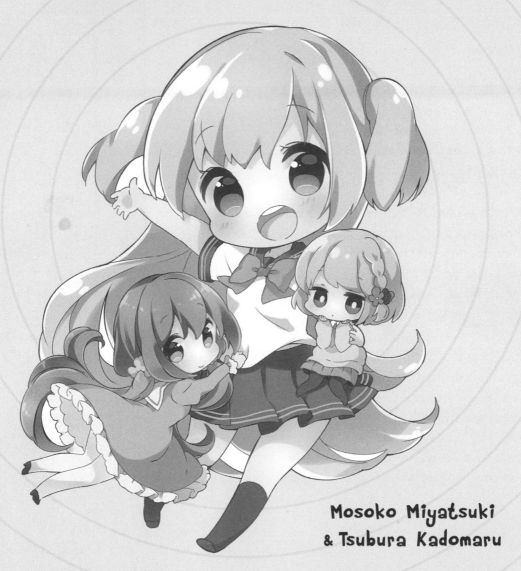

Mosoko Miyatsuki
& Tsubura Kadomaru

TUTTLE Publishing

Tokyo | Rutland, Vermont | Singapore

T0108014

CONTENTS

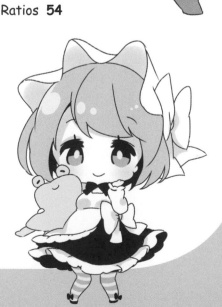

CHAPTER 4: **Drawing Chibi Faces**

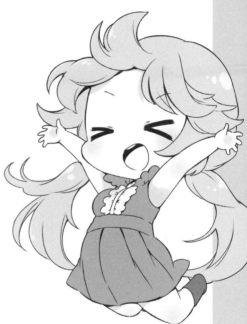

CHAPTER 5: **Expressing Chibi Emotions**

CHAPTER 6: **Inside the Artist's Studio**

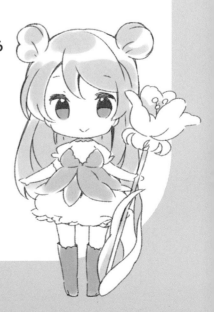

Get Your Pen And Paper Out, Because It's Chibi Time

Maybe your first thought is: But I don't know how to draw these adorable mini characters. That's all about to change.

What do you think about when drawing manga or anime characters? For some artists just starting out, it's rules, rules, rules. Body size, proportion, balance. Of course the rules of illustration are important—they're there for a reason—but in chibi world, the rules are bent, the proportions distorted.

Many books on drawing methods and techniques place the importance on proportion. Deciding on the proper proportion from the get-go prevents the head from being too large or small. It also saves you from ruining the overall balance as you proceed deeper into the illustration.

However, when drawing chibi (or any caricature-style characters with intentionally disproportionate bodies and features) many people leave things to guesswork. As a result, they end up wondering why the figures they've created seem off kilter, out of balance. Or worse, they don't come out as originally intended. When drawing mini characters, it's important to consider their proportions and scale down the parts and features accordingly. Here, you'll learn how to draw chibi cuties of three different sizes: 2, 2.5 and 3 heads tall.

At 2 heads tall, a figure is small and cute with a big head. A figure 3 heads tall has longer, more flexible limbs. A character that's 2.5 heads tall generally comes off as well-balanced. Each size has its own appeal and attributes, depending on the look and proportions you're going for. If you can draw each according to their sizes, your chibi characters will be more vibrant and full of movement, exuding the playful charm that defines them.

Ready to head out on your chibi adventure? Got that pen in hand and your paper or sketchpad in front of you? At first you'll take small steps, chibi-sized steps as you learn the essentials and become familiar with the process. Before you know it, you'll be dashing off adorable chibi cuties all your own. Let's go!

1

Let's Start with the Basics

What kinds of mini characters are there and what are their characteristics? How are they different from realistic characters? Let's learn the tricks you need to master to draw them. And of course we have to start at the very beginning!

When you're first starting out or beginning a drawing you have entirely planned out beforehand, there's a tendency to look at the tip of the pen. Instead, practice looking at where the pen's headed to get a better understanding of the overall picture. Whether you're using a mechanical pencil and paper or a pen tablet, the method's the same.

▶▶▶ Moving the pen, step by step

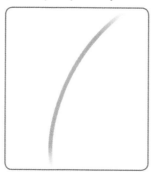

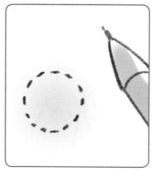

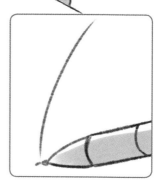

1. Rather than suddenly drawing onto a blank piece of paper, first visualize the type of line you want to draw.

2. Here, a soft, short curve is needed. Consider the direction from which it will be easiest to draw the line (in this case, from top right to bottom left).

3. Place the pen to the top right and don't look at the tip of the pen but where it'll go and then visualize the line again.

4. Draw the line in one stroke as if bringing a vision to life.

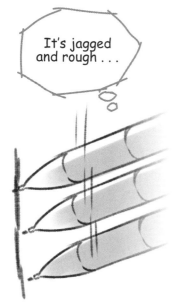

It's jagged and rough . . .

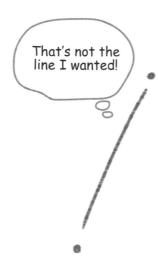

That's not the line I wanted!

This one's wobbly!

In Step 1, if you suddenly start drawing, the line will be indirect and unruly.

In Step 3, if you're only looking at where the line will end up, you'll be able to draw the line, but it won't turn out the way you initially envisioned.

If you're only looking at the tip of the pen, you won't have a clear idea of where it's going, so your line will wander.

▶ ▶ ▶ Applying Pen Pressure

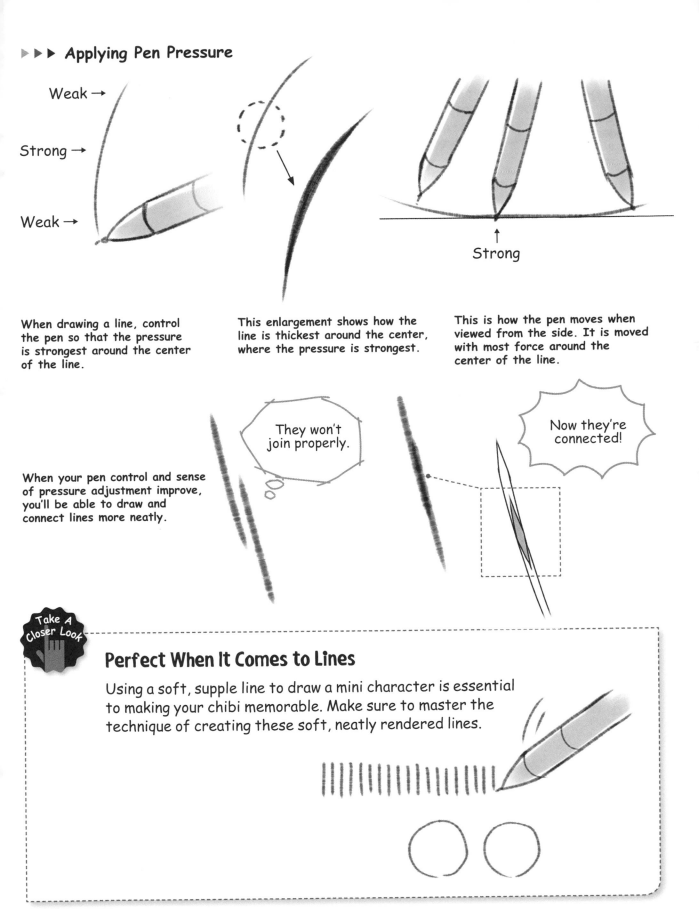

Weak →

Strong →

Weak →

Strong

When drawing a line, control the pen so that the pressure is strongest around the center of the line.

This enlargement shows how the line is thickest around the center, where the pressure is strongest.

This is how the pen moves when viewed from the side. It is moved with most force around the center of the line.

They won't join properly.

Now they're connected!

When your pen control and sense of pressure adjustment improve, you'll be able to draw and connect lines more neatly.

Take A Closer Look

Perfect When It Comes to Lines

Using a soft, supple line to draw a mini character is essential to making your chibi memorable. Make sure to master the technique of creating these soft, neatly rendered lines.

DRAWING FIGURES WITH DIFFERENT HEAD-TO-BODY RATIOS

Altering how much you exaggerate the figure's proportions and the overall balance of the physique—depending on the head-to-body ratio—allows you to distinguish between the various sizes of mini characters.

Compare the Levels of Exaggeration and Distortion

Let's compare the different degrees to which the various figures are altered.

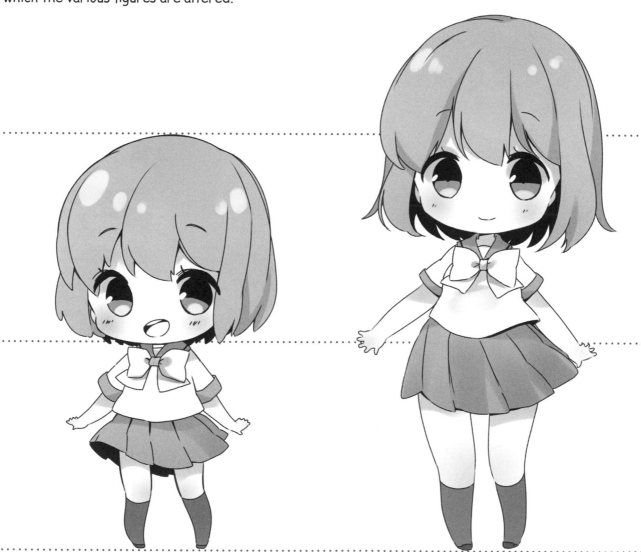

2 HEADS TALL

Figures at this head-to-body ratio exhibit the highest degree of distortion. Make the head and eyes the biggest and leave out a lot of the fine details. It's important to consider carefully what to omit and what to leave in.

2.5 HEADS TALL

Figures of this head-to-body ratio occupy a space between those 2 heads tall and 3 heads tall. The eyes are positioned low on the face and the cheeks are adorably rounded. The body isn't small, though, so the clothing can be used to add detail and visual appeal.

▶ ▶ ▶ There Are Two Types of Figures 3 Heads Tall

Decide on a pivot point, then move your arm or hand like a pendulum to draw a line. The pivot point will change depending on the length of the line.

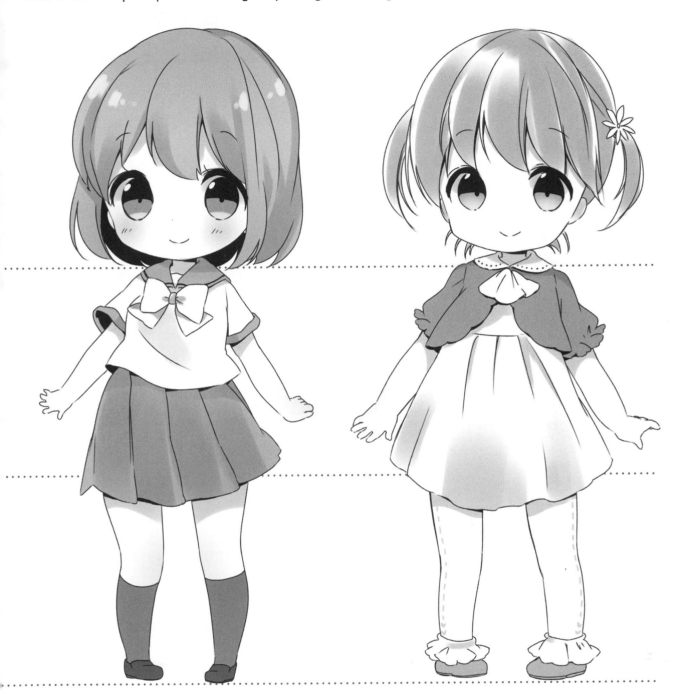

3 HEADS TALL

The level of distortion and exaggeration isn't extreme, so figures at this ratio are easier to draw even for beginners. The head section can be the same as for figures that are 6 to 7 heads tall.

3 HEADS TALL (with a child's physique)

For characters at this ratio, the physique is similar to that of an infant. Clearly draw in the neck, the width of the shoulders and the ends of limbs and add details to the clothes, hair and other key parts.

Drawing mini characters without clothes, hair and other details clearly reveals the differences in the overall balance of their physiques. Let's compare bare forms at each head-to-body ratio.

2.5 HEADS TALL (Basic Type)

The figure is pear-shaped, with chubby, rounded buttocks and stomach. The waist is positioned at about half the height of the head.

Waist

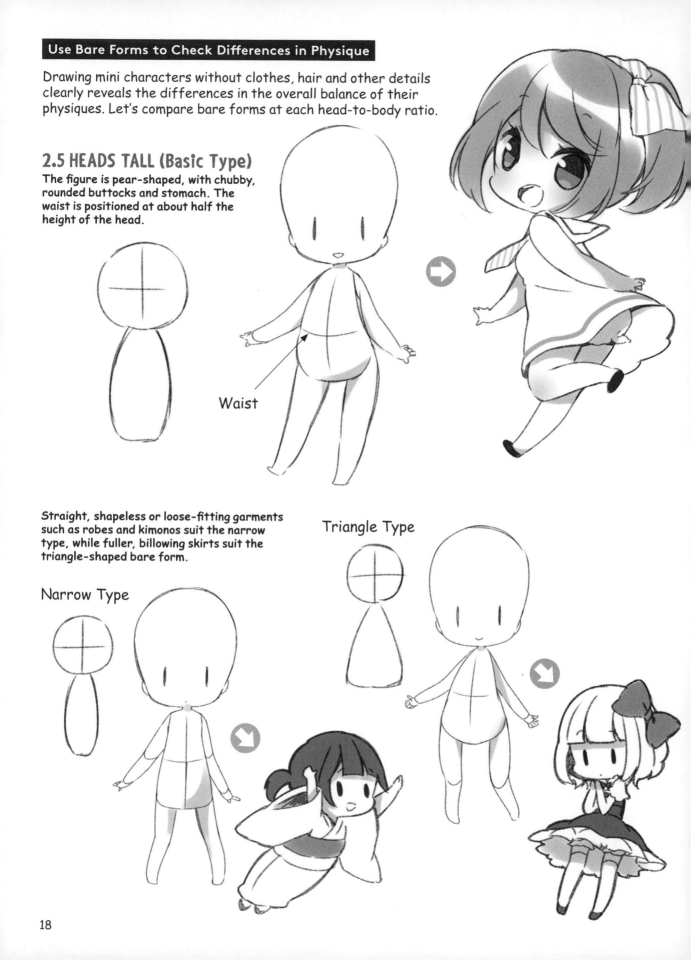

Straight, shapeless or loose-fitting garments such as robes and kimonos suit the narrow type, while fuller, billowing skirts suit the triangle-shaped bare form.

Triangle Type

Narrow Type

2 HEADS TALL

The roundness of the buttocks and the fullness of the stomach are particularly emphasized in this pear-shaped physique. The waist position is a bit higher than half the head height.

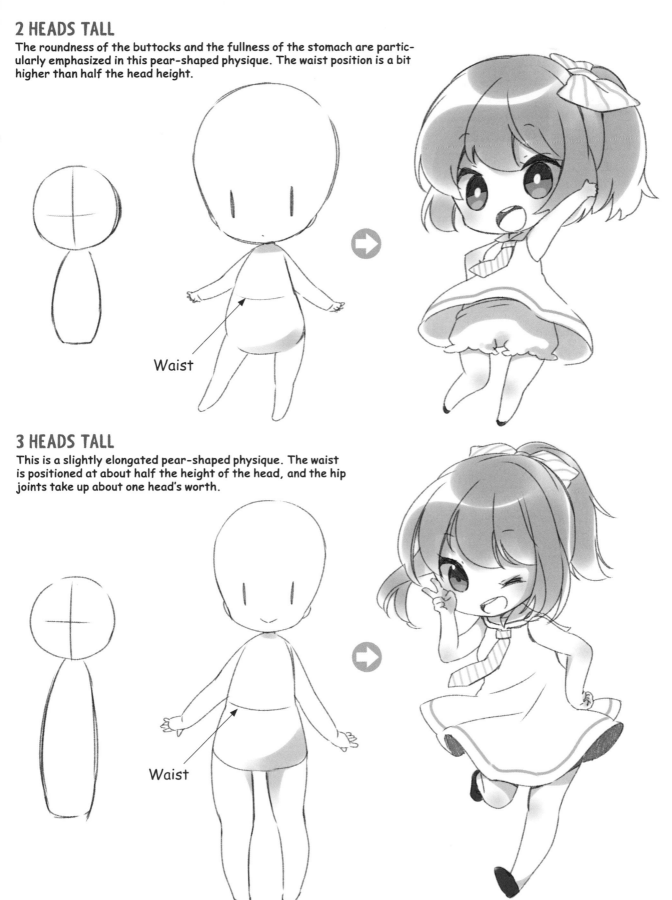

Waist

3 HEADS TALL

This is a slightly elongated pear-shaped physique. The waist is positioned at about half the height of the head, and the hip joints take up about one head's worth.

Waist

EXPRESSING SOFTNESS

The soft, rounded, fuller contours of chibi bodies is what makes them so cute and appealing. Let's take a look at how to enhance this quality in your mini-creations.

Practice Drawing Soft Lines

One of the simple tricks to remember for chibi success? Soften the rigid edges of traditional shapes. Practice these simple distortions to add suppleness and appeal to your characters.

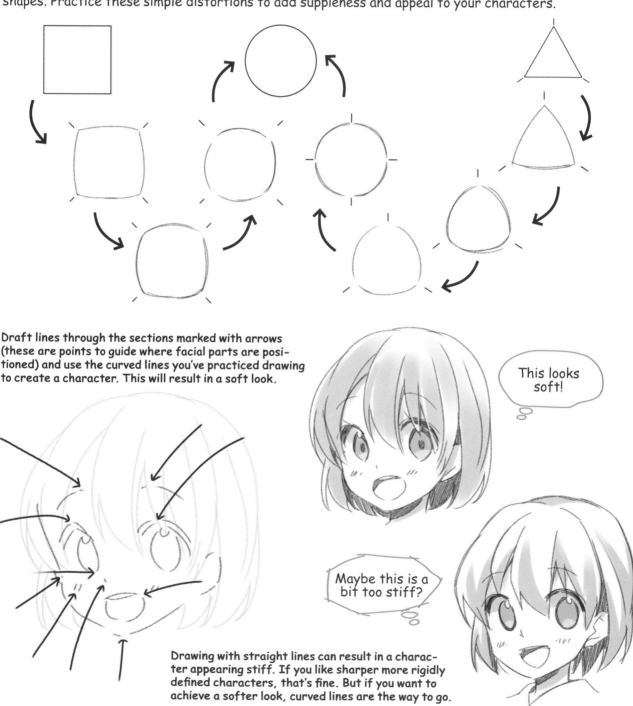

Draft lines through the sections marked with arrows (these are points to guide where facial parts are positioned) and use the curved lines you've practiced drawing to create a character. This will result in a soft look.

This looks soft!

Maybe this is a bit too stiff?

Drawing with straight lines can result in a character appearing stiff. If you like sharper more rigidly defined characters, that's fine. But if you want to achieve a softer look, curved lines are the way to go.

Characters with a 2.5 Head-to-Body Ratio

It's time to try your hand at drawing figures 2.5 heads tall, the ideal head-to-body ratio for those just starting to draw mini characters. Mastering these proportions will help you to draw other ratios and variations as well.

Chibi characters look awkward with long necks. Either make them short or omit them almost entirely. Narrowing the shoulders brings out your character's charm and appeal.

▶▶▶ **Tips for the Neck and Shoulder Area**

The neck is short and the shoulders are narrow and tapered.

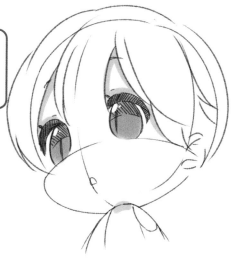

Think of a mini character's neck as protruding from the body like on a bobblehead figure. Draw the head and neck as if they're two pieces being assembled, clicked into place.

Once the head is properly positioned, the neck won't be visible. However, it's important to remember that even if it can't be seen, it's still there, positioned behind the middle of the head.

In poses where the head is turned to one side, the neck isn't visible, so draw only the turned head.

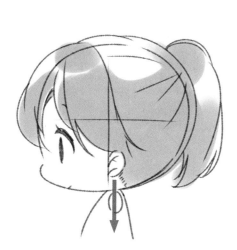

For a realistic-looking character, the neck is attached to the head on a slanted angle, but a mini character's head sits straight, positioned on the torso just beyond the center of the head.

Create width for the shoulders but make them slope in an exaggerated fashion.

Making the shoulders straight across gives the body a square look that fails to evoke the contours of a mini character.

26

▶ ▶ ▶ Drawing Collars

Given that chibi characters' necks typically aren't visible, the problem arises of how to draw collars and scarves that envelop the neck. The solution is to either draw it the width of the shoulders or so it covers the chin.

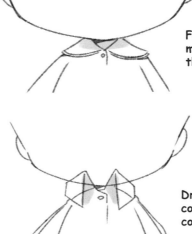

For regular collars with not much height, draw them to the width of the shoulders.

Draw upturned collars, tall collars and scarves so they cover the chin.

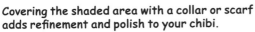

Covering the shaded area with a collar or scarf adds refinement and polish to your chibi.

Various examples of collars and neck treatments. Even if the neck isn't visible, it's still possible to express fashion at the neckline.

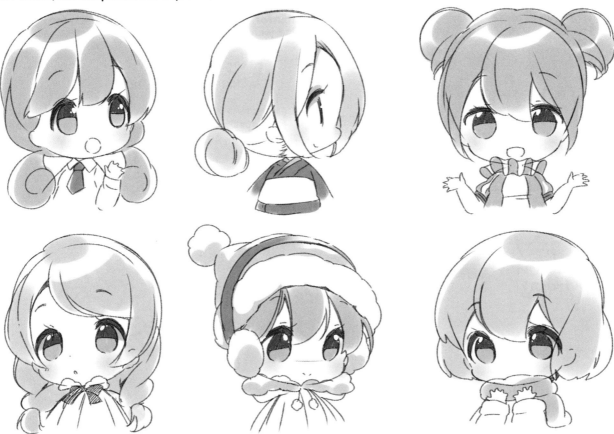

27

BASIC POSE FOR CHARACTERS 2.5 HEADS TALL

Now let's draw a basic standing pose, making sure the hip and shoulder widths and limb ratios and positions are right as you proceed. It's a good idea to use a large piece of paper when starting out.

Draw the Frontal View

▶▶▶ **Steps for blocking-in**

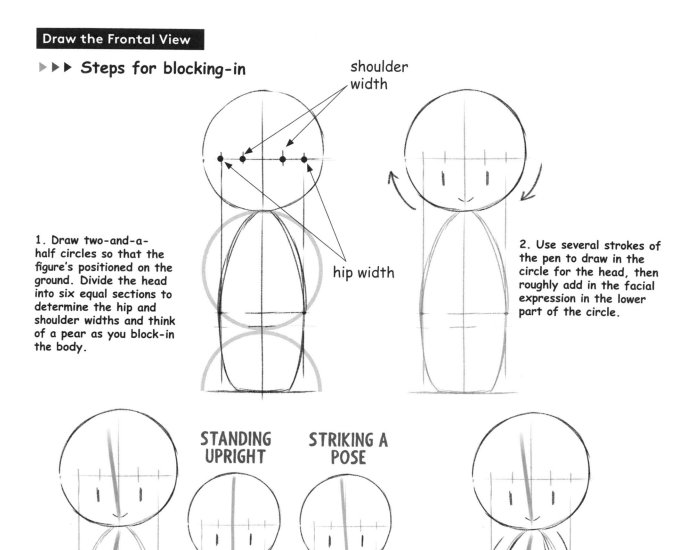

shoulder width

hip width

STANDING UPRIGHT

STRIKING A POSE

1. Draw two-and-a-half circles so that the figure's positioned on the ground. Divide the head into six equal sections to determine the hip and shoulder widths and think of a pear as you block-in the body.

2. Use several strokes of the pen to draw in the circle for the head, then roughly add in the facial expression in the lower part of the circle.

3. Consider the body's central axis as you block-in the figure. When standing upright, the figure's axis is directed straight up from the ground. When striking a pose, the axis is tilted.

4. Create the shape of the torso. At this stage, rather than making lots of small strokes, draw them in softly using one stroke for each curved line.

▶▶▶ Steps for Drawing Limbs

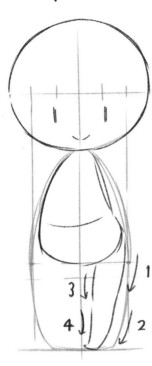

Create the legs in three blocks, tapering toward the ends of the feet.

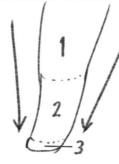

The figure has ankles, but don't draw them in.

1. Here, the weight rests on the left foot, so the legs aren't symmetrical. Balance the figure as you draw, taking care where the sole of the foot rests and how it's angled.

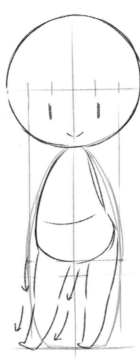

2. Use one stroke of the pen each for the sections of the leg from the hip joint to the knee and the knee to the ground. Rather than drawing clearly protruding knee joints, simply sketch in a sense of where they're positioned.

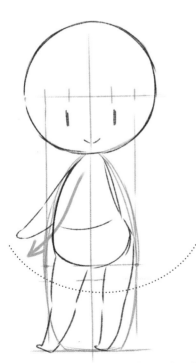

As for the legs, block the arms into three sections. Think of the fingers as separate parts.

Draw each finger separately from the back of the hand. Rather than drawing each finger an equal distance apart, position the thumb slightly farther from the other fingers.

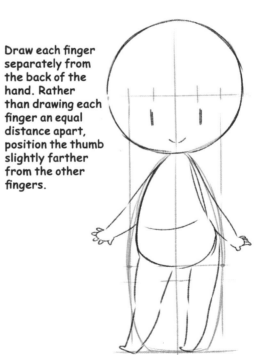

3. Block-in the arms. The ends of the hands come to roughly the point where a curved line is traced through the crotch. The elbows are at the midpoint of the arm between the shoulder and wrist.

4. Draw the left arm in the same way. Some chibi characters don't have fingers, but drawing in even short fingers makes for a mini-figure with a greater sense of presence and definition.

▶▶▶ Steps for Drawing Clothes

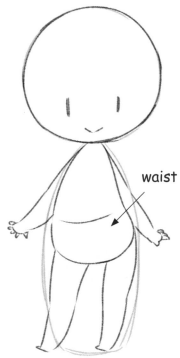

The skirt is drawn with the waist as a starting point, so even if the waist doesn't narrow, it's important to know its position.

waist

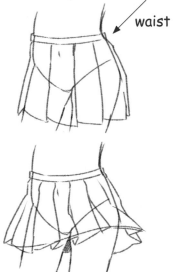

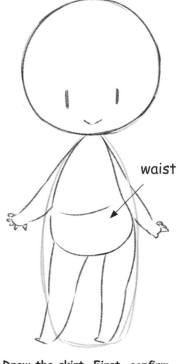

1. Draw the skirt. First, confirm the position of the waist. It should be about 1.5 heads down from the crown of the head.

2. Making the overall silhouette a triangle makes your character more appealing, so create a wide hem to form this shape.

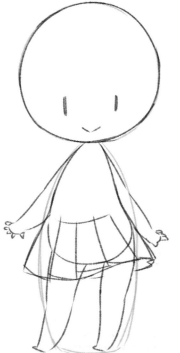

Don't simplify the unevenness of the pleats.

Take a Closer Look

For figures 2 heads tall or less, it's fine to leave out the pleats or eliminate the unevenness at the hem.

3. Draw in the pleats as if dividing the skirt into sections. For a figure 2.5 heads tall, draw in the inner edges of the pleats as well.

width of the neck

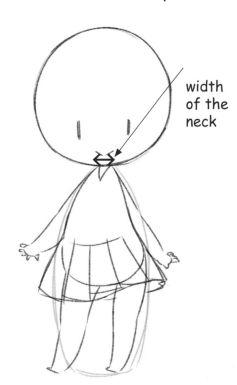

4. Draw a V shape the width of the neck to create the collar.

Draw in this order:
collar knot bow

shirt cuff

6. For a sailor-style outfit or school uniform, first decide where the shirt cuffs will be and then add the details. Making the material appear thick brings out a sense of dimension.

5. Draw in the collar section, keeping the sloping shoulders in mind. Make the bow large so that it really stands out.

All finished!

Emphasize this area

7. Draw the shoes. In order to create the look of loafers, emphasize the top part (the vamp and tongue) and omit the heel.

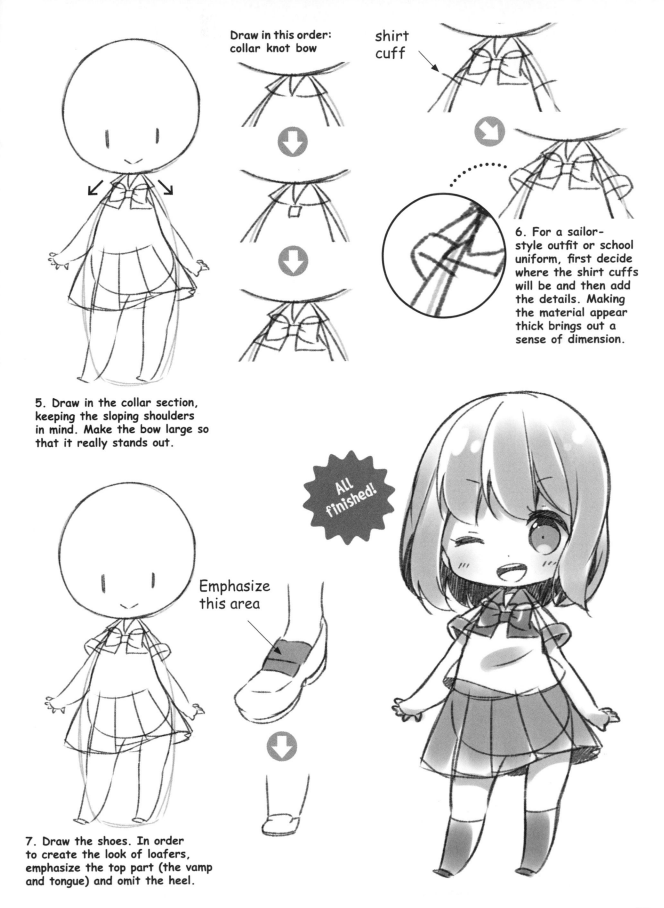

33

Let's take a look at the process of drawing the bare form of a figure 2.5 heads tall. Pick up your pen and follow along with the artist, building your form stroke by stroke and step by step.

Draw a circle to block-in the head. Don't make lots of short, rough lines, but instead go for four smooth strokes. Draw a cross in the center of the circle.

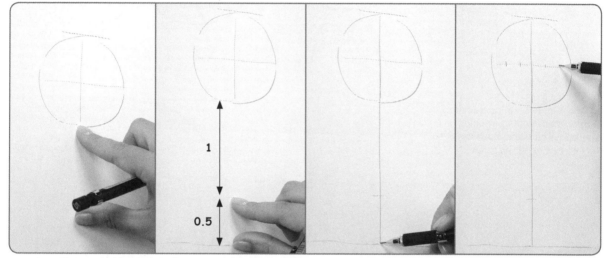

Measure the circle's diameter using your finger and make horizontal lines one full circle down and then another half circle down resting on what will become the ground. Make a straight line through the center of the circle, perpendicular to the ground, and divide the circle horizontally into six equal sections.

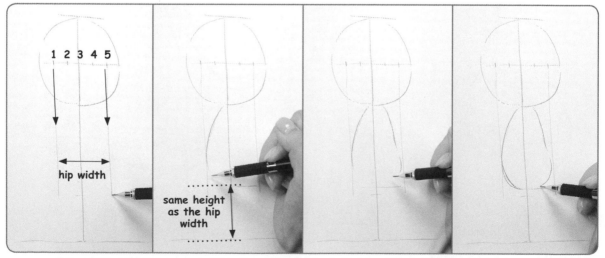

Extend lines down from 1 and 5 to form the width of the hips. Block-in the inner legs, making them the same width as the hips to create a pear-like figure.

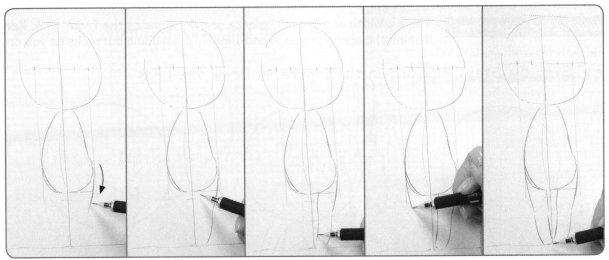

Draw the legs to connect smoothly from the buttocks. Be conscious to use an S shape rather than making the legs straight. Use a mirror-image S shape for the other leg.

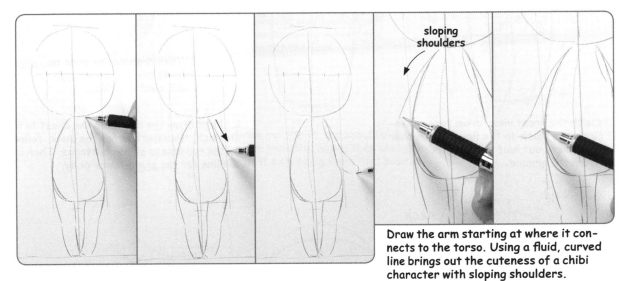

sloping shoulders

Draw the arm starting at where it connects to the torso. Using a fluid, curved line brings out the cuteness of a chibi character with sloping shoulders.

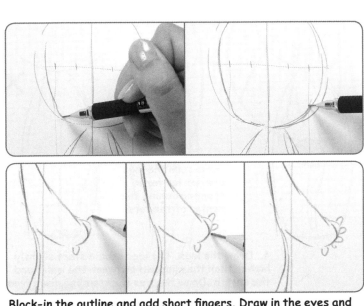

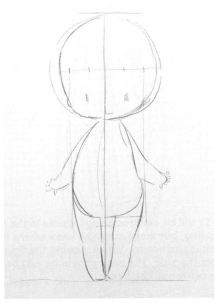

Block-in the outline and add short fingers. Draw in the eyes and adjust the overall figure to complete the bare form.

Divide the skirt using vertical lines . . .

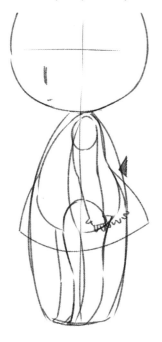

Add the inner folds of the pleats to create crisply defined edges.

1. Draw the skirt. Make sure to create a triangular silhouette from the torso to its hem.

2. Draw in the pleats using vertical lines, then alter the hemline to indicate the ends of the pleats.

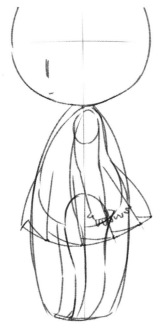

Actual skirt pleats look like this.

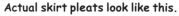

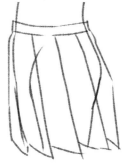

line along the lower chest →

flatten the clothing →

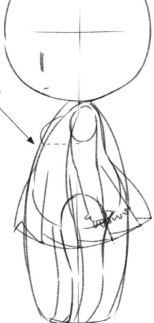

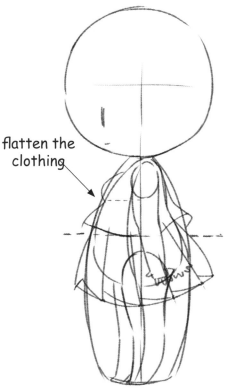

For chibi characters, flare the skirt out slightly.

3. Create the chest or bust. The line defining the bottom of the chest area should be slightly lower than the underarm.

4. Draw in the top so that it ends around the waist. Bringing the clothing in flush with the body around the lower chest defines and emphasizes the bust.

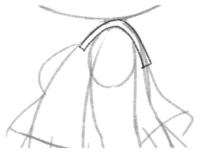

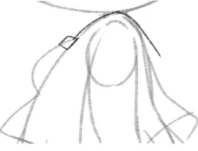

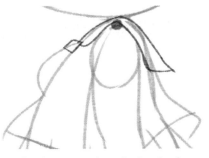

5. Draw the sailor collar. The collar covers the area from the shoulders to the back (the section marked as an arched shape).

6. Draw the knot of the bow on the chest and work out where the collar will sit on the shoulders.

7. Emphasizing that the back of the collar is flapping up slightly away from the body makes it clear that it's a sailor uniform.

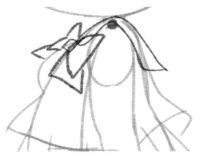

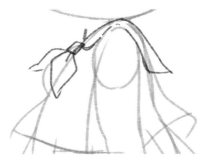

If drawing a scarf, it will look like this.

8. Draw the bow with the knot at the center.

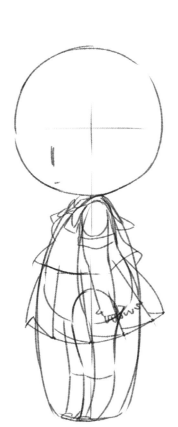

All finished!

Even though the feet are small, drawing in the tongue of the shoe makes it clear that they're loafers.

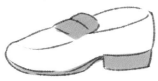

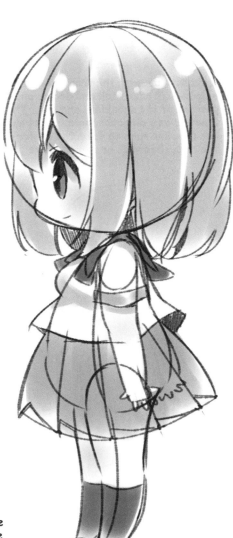

9. Neaten up the fine details such as the shoes.

10. Draw in the details for the head and add tone to finish. Darkening the areas of shadow will make for a more solid, dimensional character.

▶▶▶ Step by Step: Drawing the Arms and Clothing

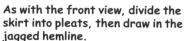

As with the front view, divide the skirt into pleats, then draw in the jagged hemline.

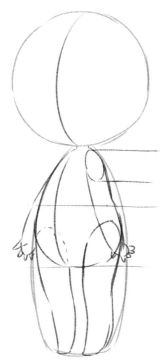

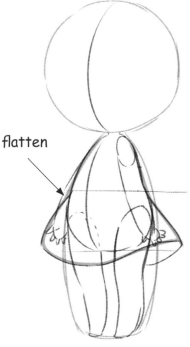

flatten

1. Draw both arms and neaten up the limbs, being conscious to create S-shaped curves rather than straight lines.

2. Draw the clothes, creating a triangular silhouette that tapers slightly at the waist.

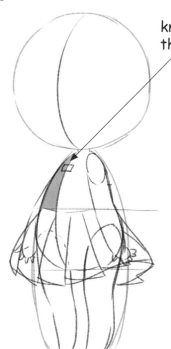

knot for the bow

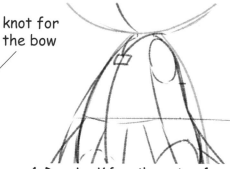

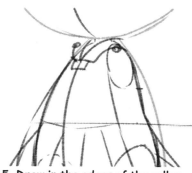

3. Draw the sailor uniform. The knot for the bow sits at the center of the body, so draw it on top of the median line.

4. Draw in a V from the center of the bow to both sides of the neck.

5. Draw in the edges of the collar, working up toward the arm joints.

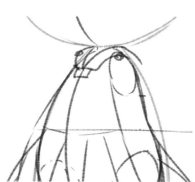

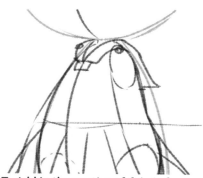

6. Draw in the section of the collar that rests on the shoulders.

7. Add in the section of fabric for the back of the collar.

First, draw in the shape created by the cuffs to work out the rest of the sleeve.

Only a small part of the sleeve on the back arm is visible.

sleeve

use a dark color

9. Fill in the details to create the conical look of the sleeve, using a dark color for the inside shadows to bring out dimension and depth.

8. Add in the bow and adjust the overall look of the sailor uniform.

All finished!

Draw in the tongue and back of shoe, omitting everything else.

10. Draw the shoes. As with the front view, add in the tongue to create the look of loafers.

11. Add shadow cast by the skirt on the thighs and shadow cast by sleeves on the arms to create dimensional density.

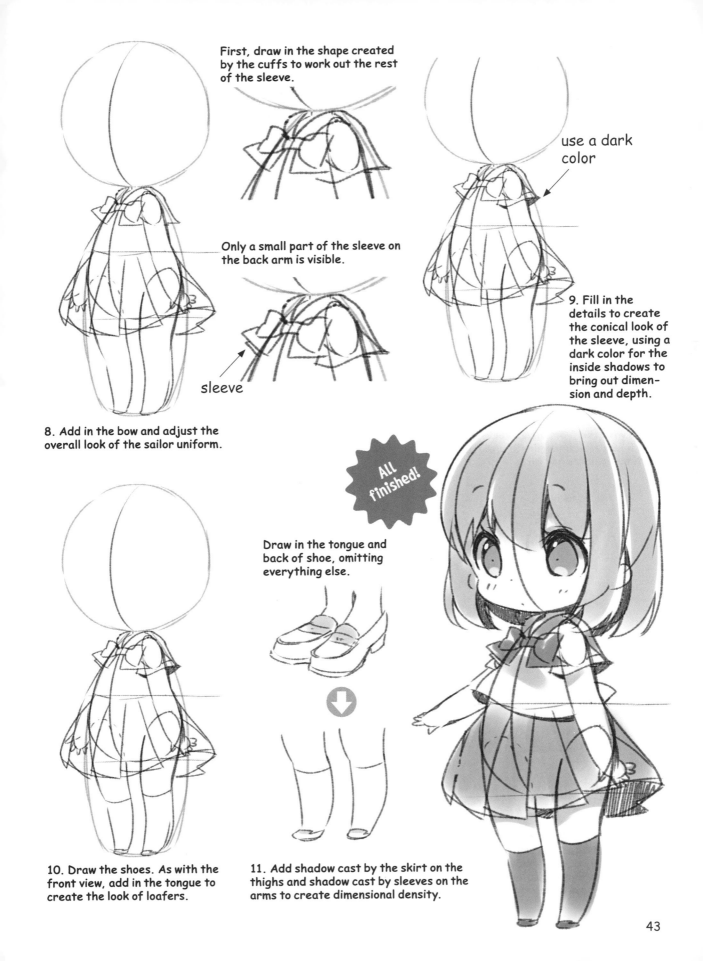

VARIATIONS ON CHARACTERS 2.5 HEADS TALL

The basic character that is 2.5 heads has a plump, charmingly rounded physique.
Let's look at variations on this form, each of which appeals in a different way.

Try Drawing a Triangle-Shaped Body

The reason that broad hips make for a cute look is because they evoke
the image of a baby wearing a diaper. Here, try drawing a triangle-shaped
figure with hips even wider than those of the basic type.

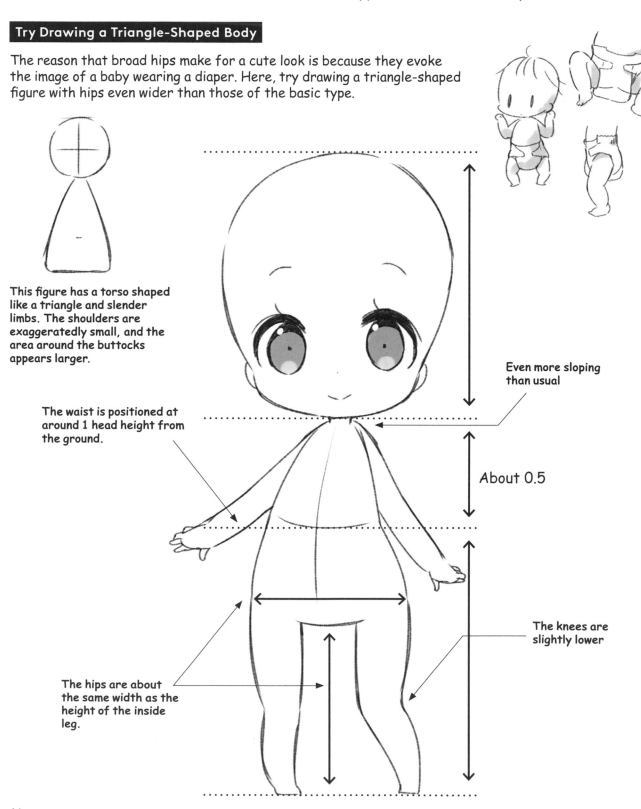

This figure has a torso shaped
like a triangle and slender
limbs. The shoulders are
exaggeratedly small, and the
area around the buttocks
appears larger.

The waist is positioned at
around 1 head height from
the ground.

Even more sloping
than usual

About 0.5

The knees are
slightly lower

The hips are about
the same width as the
height of the inside
leg.

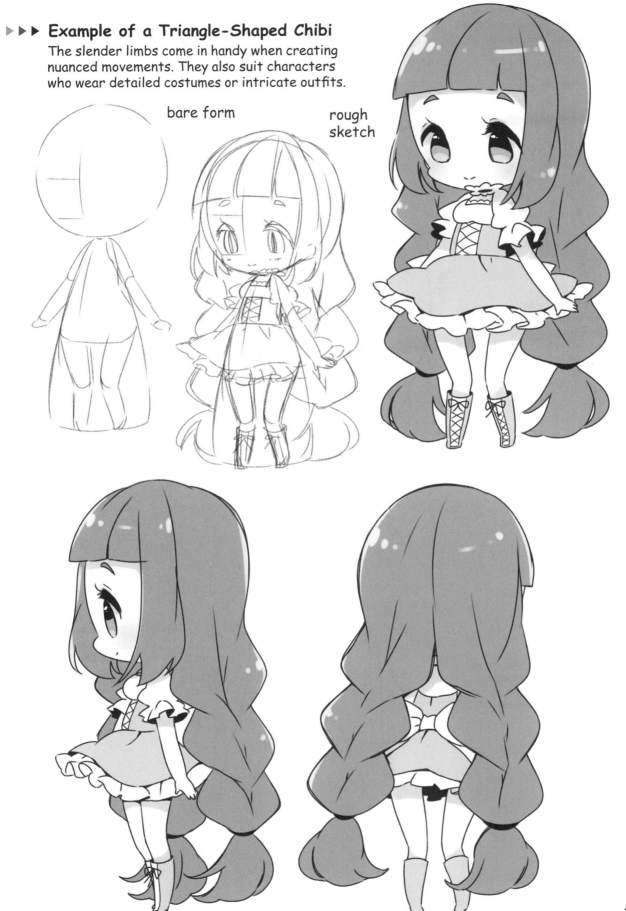

▶▶▶ Example of a Triangle-Shaped Chibi
The slender limbs come in handy when creating nuanced movements. They also suit characters who wear detailed costumes or intricate outfits.

bare form

rough sketch

STICK TO THE RATIOS FOR THE BEST RESULT!

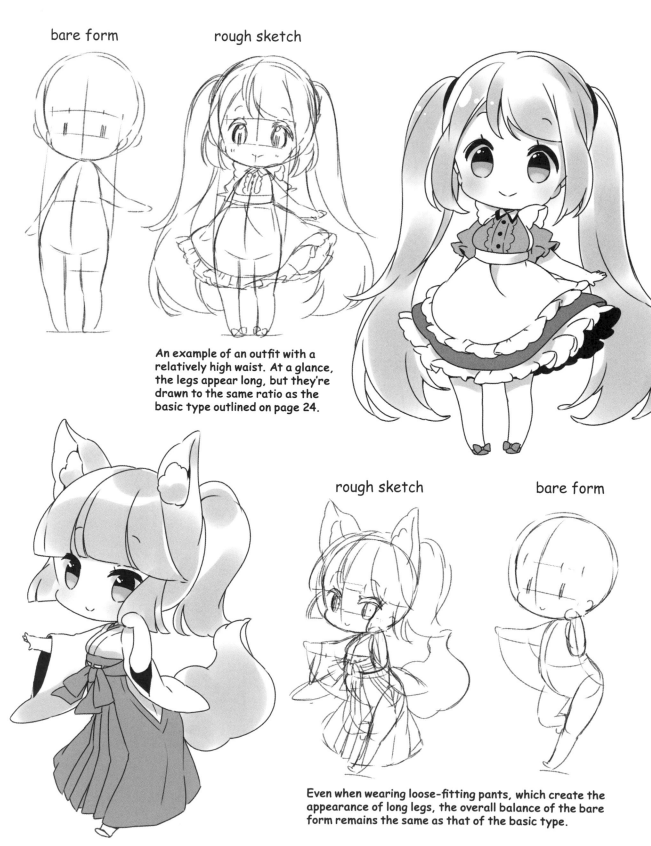

bare form

rough sketch

An example of an outfit with a relatively high waist. At a glance, the legs appear long, but they're drawn to the same ratio as the basic type outlined on page 24.

rough sketch

bare form

Even when wearing loose-fitting pants, which create the appearance of long legs, the overall balance of the bare form remains the same as that of the basic type.

Following the ratios and proportions of the bare forms introduced up to this point will prevent the figure's physique from becoming unbalanced. An out-of-balance character results in an awkward, less appealing stance and look. Until you're more familiar with creating figures, draw the bare form with proper proportions and then add in the clothing over the top.

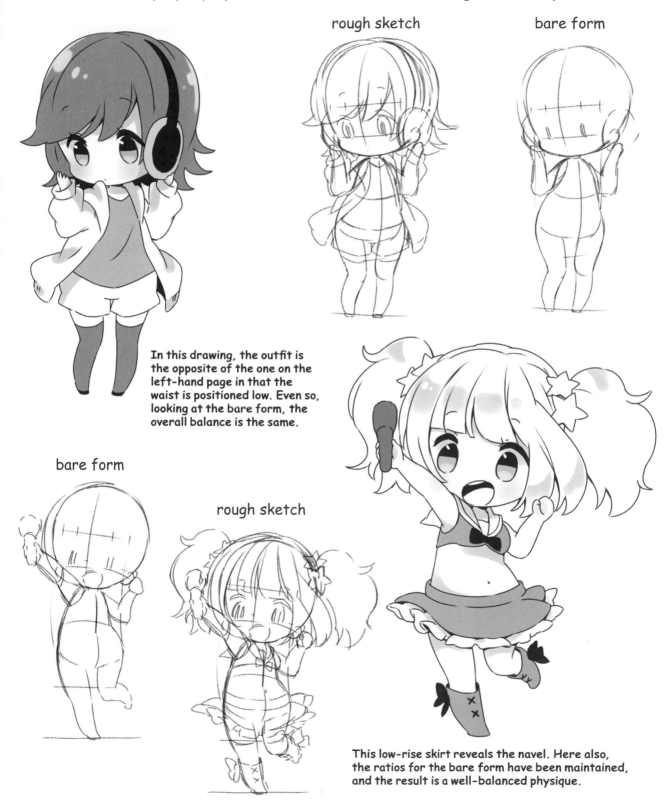

rough sketch

bare form

In this drawing, the outfit is the opposite of the one on the left-hand page in that the waist is positioned low. Even so, looking at the bare form, the overall balance is the same.

bare form

rough sketch

This low-rise skirt reveals the navel. Here also, the ratios for the bare form have been maintained, and the result is a well-balanced physique.

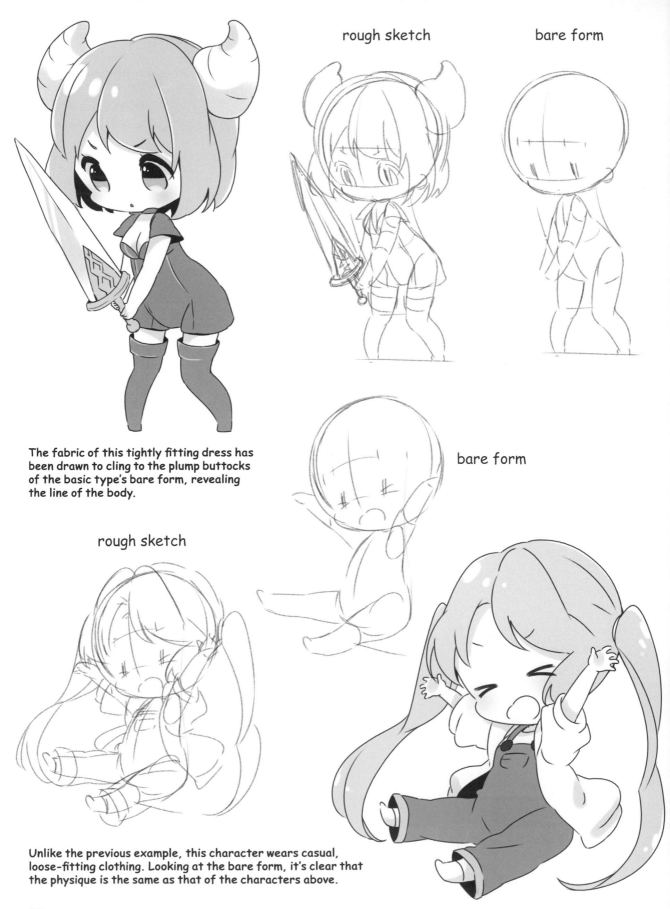

rough sketch

bare form

The fabric of this tightly fitting dress has been drawn to cling to the plump buttocks of the basic type's bare form, revealing the line of the body.

bare form

rough sketch

Unlike the previous example, this character wears casual, loose-fitting clothing. Looking at the bare form, it's clear that the physique is the same as that of the characters above.

3

Drawing Characters with Different Head-to-Body Ratios

Once you've mastered figures 2.5 heads tall, try drawing characters of other head-to-body ratios. The long-limbed, easily posable figures of 3 heads tall and the small, cute figures of 2 heads tall each have their own merits and appeal.

BASIC PHYSIQUE FOR A CHARACTER 2 HEADS TALL

About half of a chibi character's entire body is taken up by its head at this ratio, and the body becomes an exaggerated caricature. Let's look at how the torso balances with the limbs.

Make the Entire Body as Big as the Head

For characters 2 heads tall, the whole body right down to the tips of the toes fits into a circle the same size as the head. This calls for extreme distortion, so until you're familiar with this approach, try drawing on large pieces of paper.

▶▶▶ **Ratio of the Body Parts on a Bare Form**

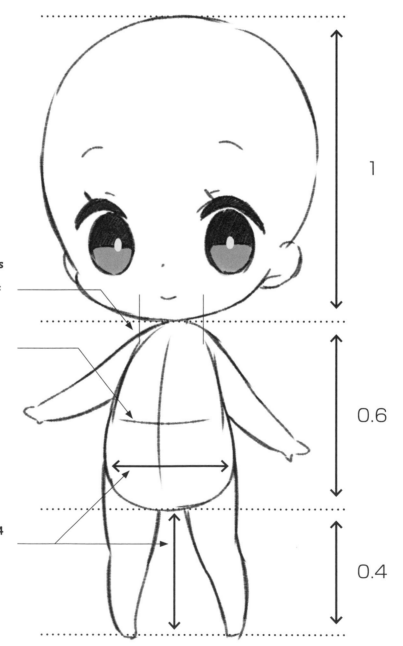

The width of the shoulders is about 0.2 of the head width, or half the width of the hips.

The length of the torso is about 0.6 of the head height. The waist is positioned halfway down.

The hip width is around 0.4 of the head width or the same length as the legs.

1

0.6

0.4

▶▶▶ Comparing Figures 2 and 2.5 Heads Tall

Let's compare the figure with one that's 2.5 heads tall to see which parts are different.

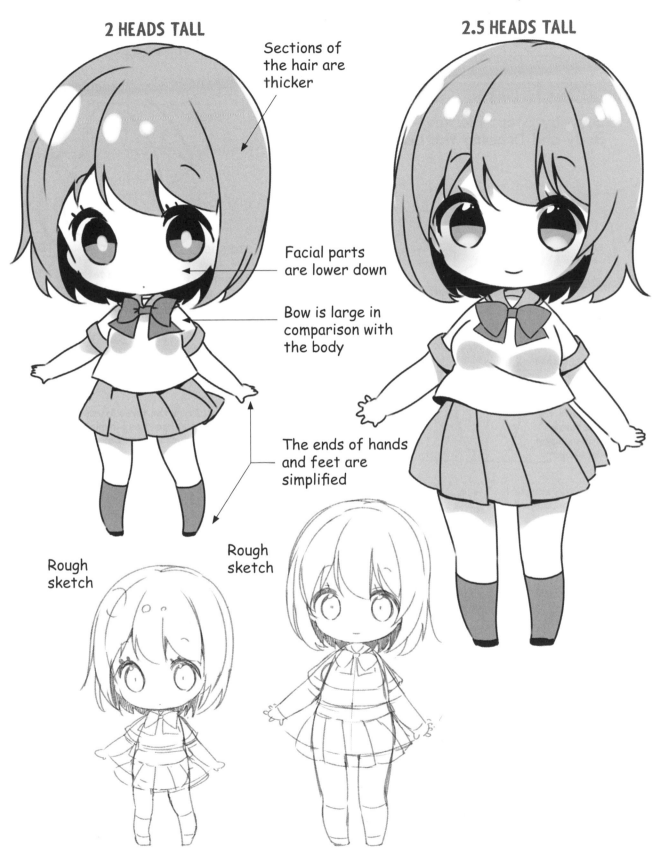

2 HEADS TALL

2.5 HEADS TALL

Sections of the hair are thicker

Facial parts are lower down

Bow is large in comparison with the body

The ends of hands and feet are simplified

Rough sketch

Rough sketch

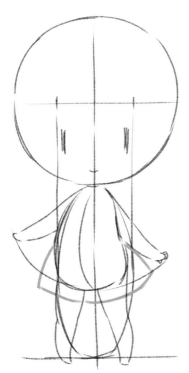

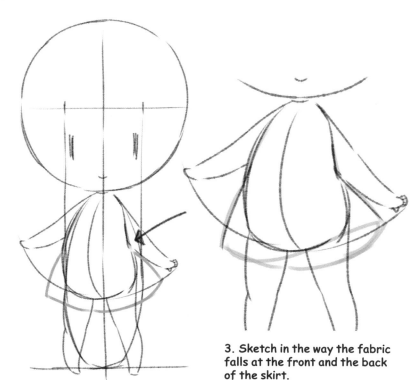

1. Draw in the clothes. The shape of the skirt should form a triangular silhouette.

2. Check the position of the waist. It should be about halfway up the torso, so start drawing the skirt from here.

3. Sketch in the way the fabric falls at the front and the back of the skirt.

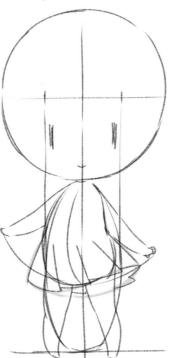

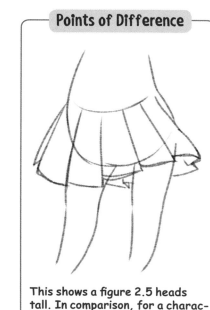

4. Make rough vertical lines to divide the skirt into pleats.

5. Draw in the hem to indicate the sharp edges of the pleats. Make the hem short to emphasize the legs.

Points of Difference

This shows a figure 2.5 heads tall. In comparison, for a character that's 2 heads tall, the pleats are clearly less defined.

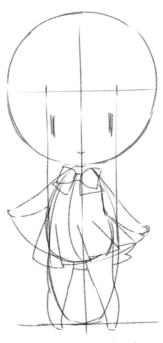

7. The detailed steps for drawing the bow start with deciding on where to place the knot.

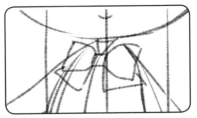

8. It's fine for the bow to extend onto the shoulders, so make it big and bold.

9. Add the ends of the ribbon beneath the bow.

10. Draw in the V-shaped neckline extending toward the knot.

6. Draw in the bow on the chest. It's difficult to make it show up properly on a small body, so make it disproportionately large in order for it to stand out.

11. Make the sailor top slightly loose so that it doesn't fit exactly to the body.

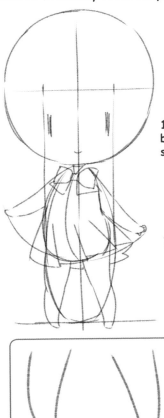

All finished!

12. Draw sleeve opening lines beneath the armpits to create the sleeves of the sailor uniform.

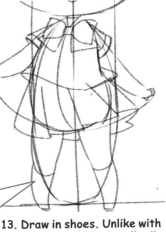

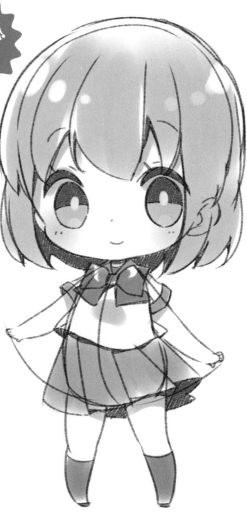

13. Draw in shoes. Unlike with characters 2.5 heads tall, all that's needed is a single line to indicate each shoe.

14. Draw in hair and the facial expression and adjust the overall balance to complete the drawing.

61

▶▶▶ Step by Step: Blocking-in the Body and Drawing the Limbs

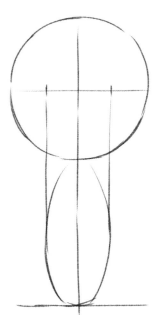

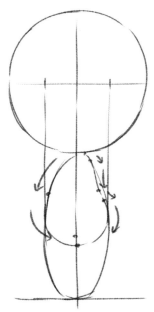

1. As with drawing the front view, indicate the ground position 2 heads down and determine the hip width.

2. Draw in the body at about 0.6 of the head height down from the chin. Viewed from the side, the stomach sticks out and the body arches slightly.

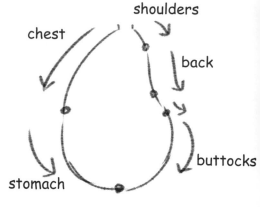

chest
shoulders
back
buttocks
stomach

Glide your pen through the form so it passes through the points marked.

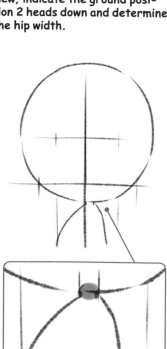

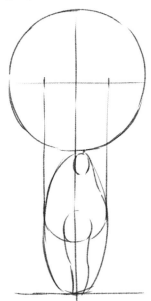

3. Determine the neck position. It connects to the body from a point just behind the center of the head.

4. Draw the legs. When the figure is standing straight, the legs extend down from the center of the torso, so make sure they're not too far in front or behind.

Let's Compare

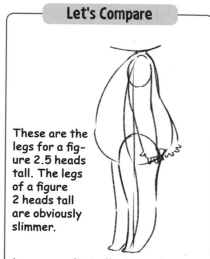

These are the legs for a figure 2.5 heads tall. The legs of a figure 2 heads tall are obviously slimmer.

Legs on realistically drawn figures appear S shaped when viewed from the side. Incorporate this shape when drawing chibi characters.

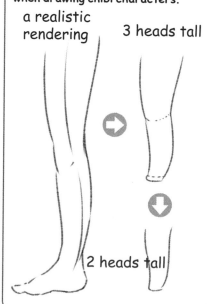

a realistic rendering

3 heads tall

2 heads tall

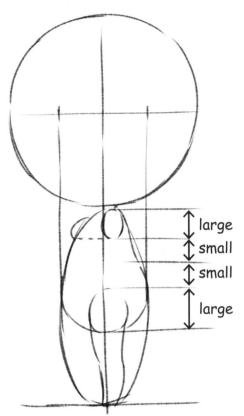

large
small
small
large

5. Check the overall balance of the body. The arm joint is slightly larger than half the distance from the neck to the waist. Similarly, the leg joint is slightly bigger than half the distance from the waist to the crotch.

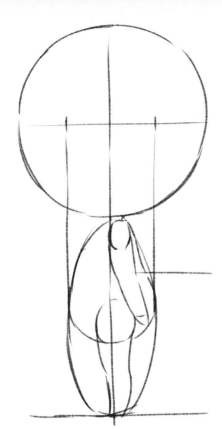

6. Draw the arm. It should be just long enough so that the fingertips don't quite reach the crotch.

Let's Compare

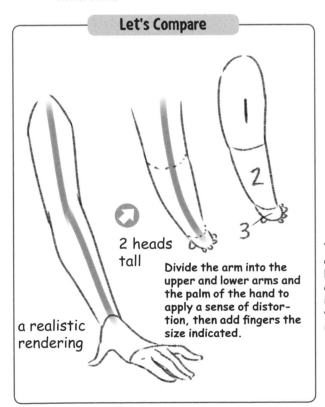

2 heads tall

a realistic rendering

Divide the arm into the upper and lower arms and the palm of the hand to apply a sense of distortion, then add fingers the size indicated.

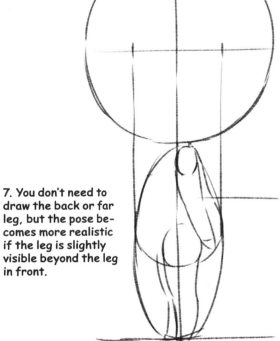

7. You don't need to draw the back or far leg, but the pose becomes more realistic if the leg is slightly visible beyond the leg in front.

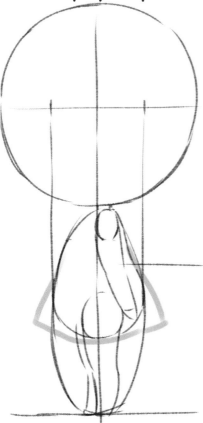

1. Draw the skirt. Visualize a triangle with the waist slightly narrowed to create the shape.

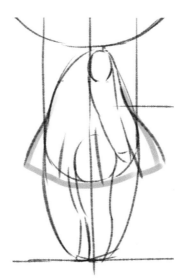

2. Roughly divide the skirt into pleats using vertical lines.

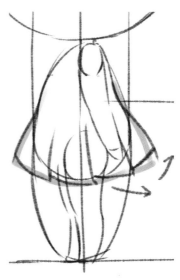

3. Draw in the hem to show the sharp edges of the pleats.

The bow viewed from the side. Compared with the front view, it looks extremely narrow.

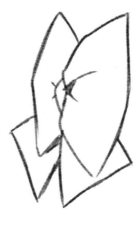

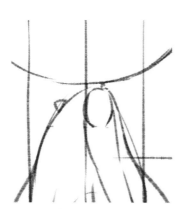

4. Draw the bow on the chest by first deciding where to place the knot.

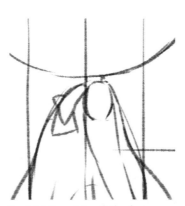

5. Add the side of the bow closest to you.

6. Then include the far side of the bow. Making it look narrow is key when drawing the bow viewed from the side.

leave this out

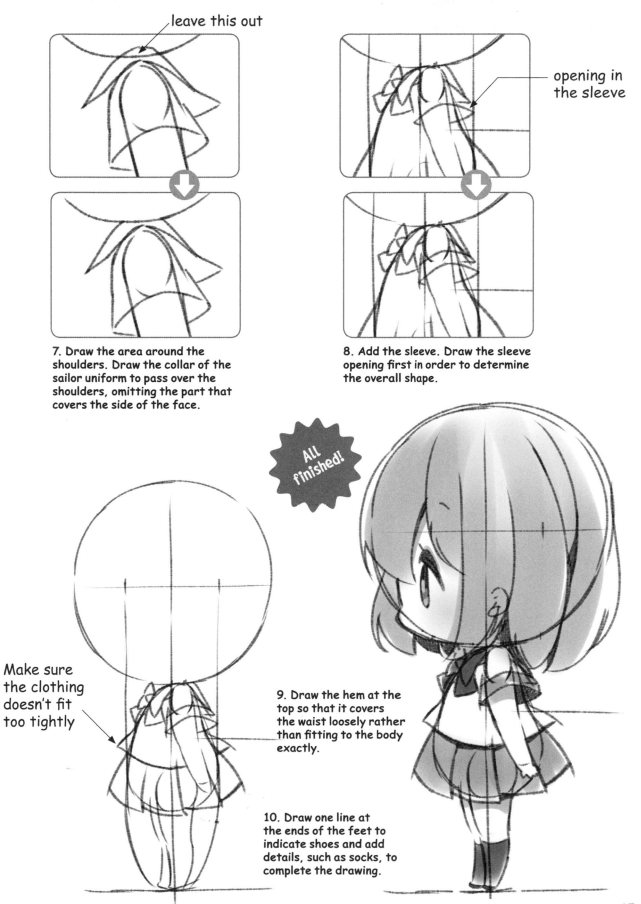

7. Draw the area around the shoulders. Draw the collar of the sailor uniform to pass over the shoulders, omitting the part that covers the side of the face.

opening in the sleeve

8. Add the sleeve. Draw the sleeve opening first in order to determine the overall shape.

All finished!

Make sure the clothing doesn't fit too tightly

9. Draw the hem at the top so that it covers the waist loosely rather than fitting to the body exactly.

10. Draw one line at the ends of the feet to indicate shoes and add details, such as socks, to complete the drawing.

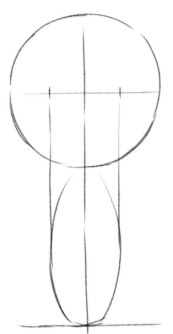

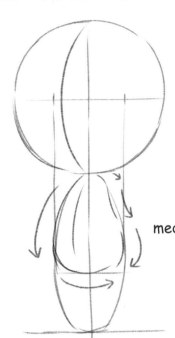

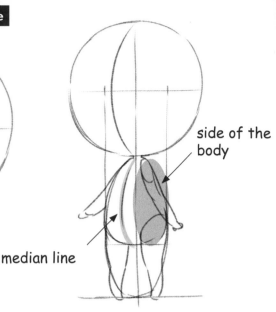

side of the body

median line

The body is on a three-quarter angle, so the median line is curved. As you keep going with your drawing, keep in mind that the side of the body appears broad.

1. Blocking-in at the start is the same as for the front and side views. Work out the width of the hips and position of the crotch.

2. Think of a pear shape when drawing the body. The waist is positioned halfway down the body.

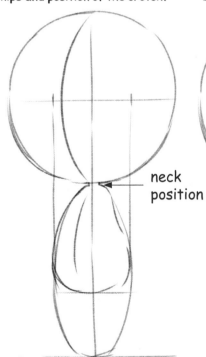

neck position

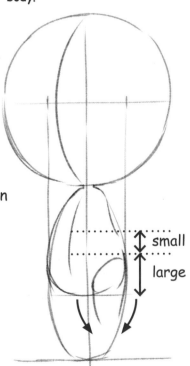

small

large

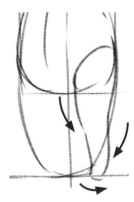

Draw the leg starting with the thigh, then the calf and sole of the foot. Add in the right leg the same way.

3. Check the position of the neck. It will actually be nearly entirely omitted, but should be positioned just behind the front half of the head.

4. Draw the legs. Make the leg joint slightly larger than half the distance from the waist to crotch and extend the leg down from there.

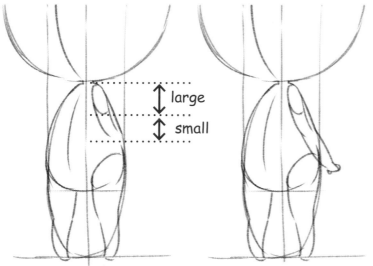

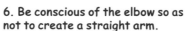

large

small

5. Draw the arm. Make the joint slightly bigger than the length halfway from the chin to the waist. Then extend the arm from there.

6. Be conscious of the elbow so as not to create a straight arm.

7. Draw the right arm too. As the body is on an angle, the right arm's concealed by the body and looks a bit short.

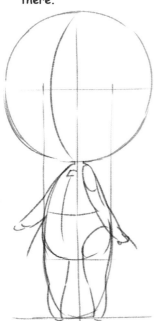

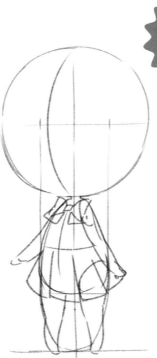

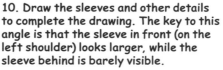

All finished!

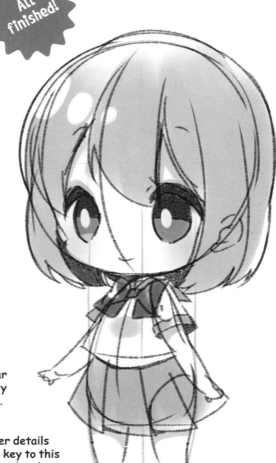

8. Draw the knot for the bow and work out the line for the waist and the shape of the skirt.

9. Making the part of the bow farthest from the viewer slightly smaller makes it appear angled. The legs are practically the same as for the front view.

10. Draw the sleeves and other details to complete the drawing. The key to this angle is that the sleeve in front (on the left shoulder) looks larger, while the sleeve behind is barely visible.

67

BASIC PHYSIQUE FOR A CHARACTER 3 HEADS TALL

Compared with the exaggeratedly distorted style of figures 2 heads tall, a softer approach is used for characters that are 3 heads tall. Let's get a grasp of the basic proportions that make them successfully come together on the page or screen.

Two Types of Figures 3 Heads Tall

Figures 3 heads tall can be either a standard chibi character or depicted with the physique of an infant. The differences are revealed in the width of the shoulders, the length of the legs and the balance of the facial elements.

▶▶▶ **Let's Compare**

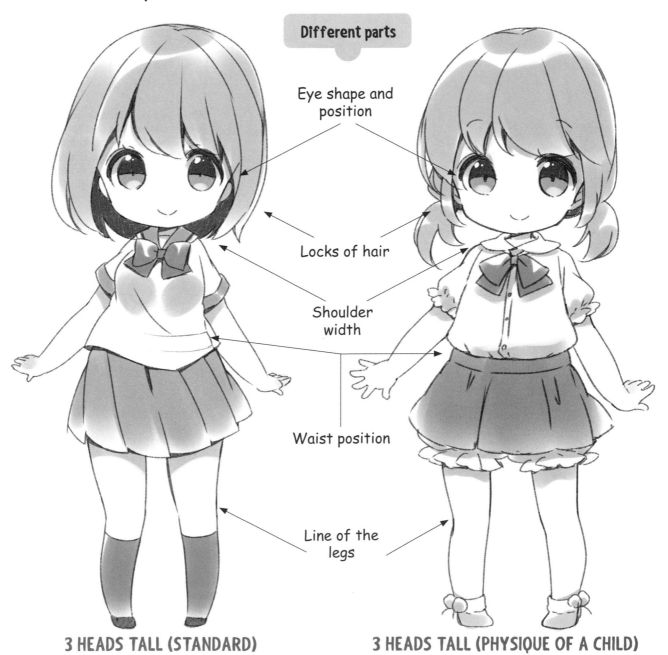

Different parts

Eye shape and position

Locks of hair

Shoulder width

Waist position

Line of the legs

3 HEADS TALL (STANDARD)

3 HEADS TALL (PHYSIQUE OF A CHILD)

Overlapping the Two Types Clearly Shows the Differences

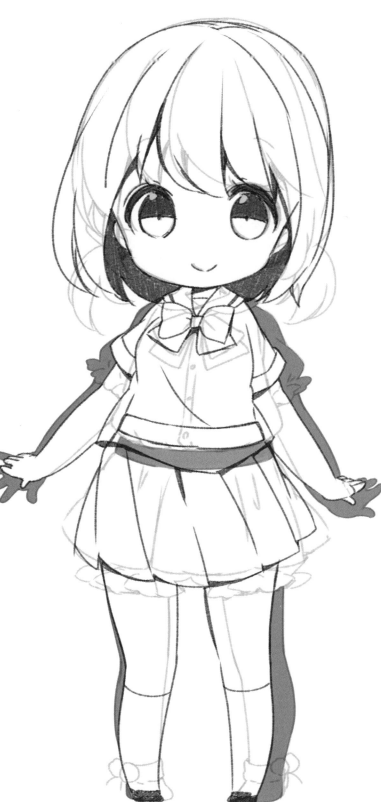

LOCKS OF HAIR

The standard type has chibi-style hair.

SHOULDER WIDTH

The standard type has sloping shoulders while the character with a child's physique has some what wider shoulders.

HAND SHAPE

The character with a child's physique has plumper hands.

LEG THICKNESS

The legs of the standard figure taper, while those of the character with a child's physique are thick all the way down.

 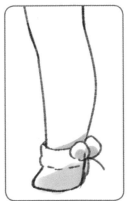

▶ ▶ ▶ Let's Compare Bare Forms

As the body and the inner-leg length are each 1 head high, the body is divided into three, making it easy to learn the basic proportions for figures of this size.

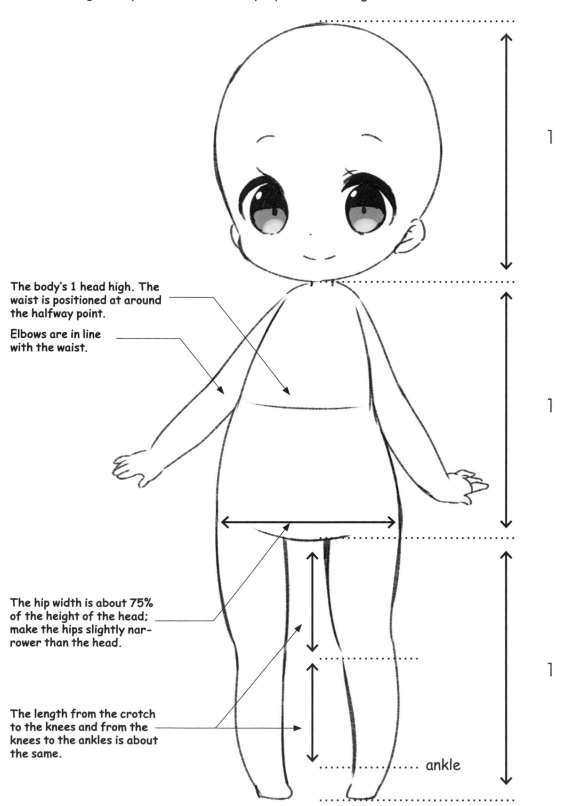

The body's 1 head high. The waist is positioned at around the halfway point.

Elbows are in line with the waist.

The hip width is about 75% of the height of the head; make the hips slightly narrower than the head.

The length from the crotch to the knees and from the knees to the ankles is about the same.

ankle

1

1

1

▶▶▶ Let's Compare Figures 3 and 2.5 Heads Tall

It's time to take a closer look at which parts differ from that of a character 2.5 heads tall.

3 HEADS TALL

2.5 HEADS TALL

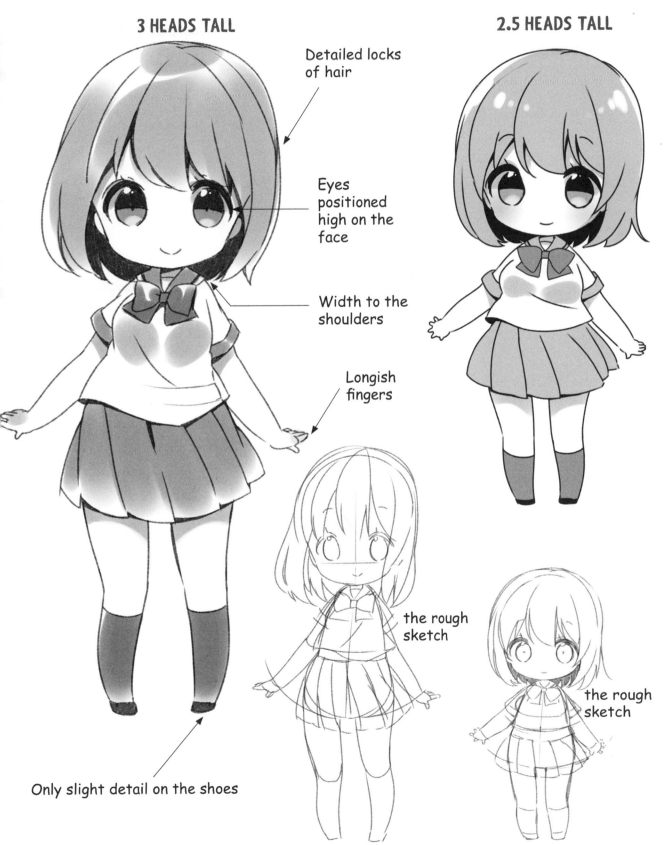

Detailed locks of hair

Eyes positioned high on the face

Width to the shoulders

Longish fingers

Only slight detail on the shoes

the rough sketch

the rough sketch

BASIC POSE FOR A CHARACTER 3 HEADS TALL

As characters at this height are only moderately distorted, there's more detail to include for the hands, hairstyle and clothing. Try to master these fine points as you draw.

Step by Step: Draw the Front View

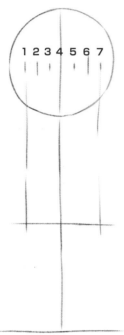

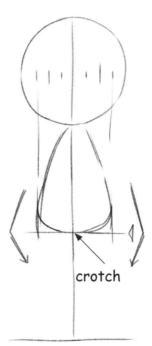

crotch

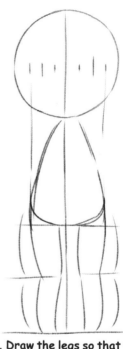

1. Use a circle to block-in the head and then draw the ground two circles' length below it. Divide the head into eight equal parts and extend lines down from 1 and 7 to determine the hip width.

2. Draw in the crotch exactly two heads' length down from the top of the head. Draw the body to resemble a rounded triangle.

3. Draw the legs so that the length from the crotch to the knees and from the knees to the feet is the same.

Let's Compare

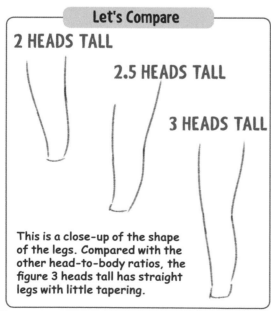

2 HEADS TALL

2.5 HEADS TALL

3 HEADS TALL

This is a close-up of the shape of the legs. Compared with the other head-to-body ratios, the figure 3 heads tall has straight legs with little tapering.

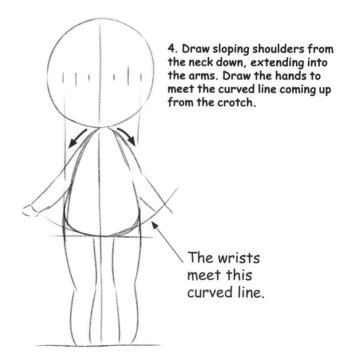

4. Draw sloping shoulders from the neck down, extending into the arms. Draw the hands to meet the curved line coming up from the crotch.

The wrists meet this curved line.

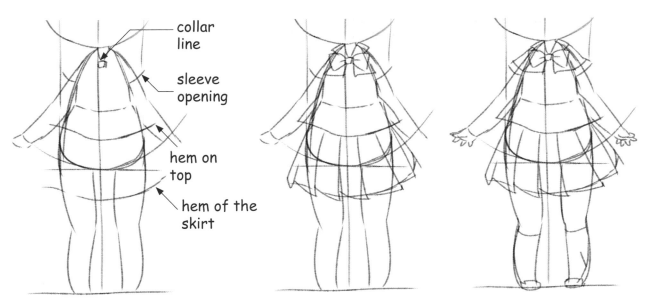

collar
line

sleeve
opening

hem on
top

hem of the
skirt

5. Draw in the sailor uniform, marking in the V of the collar line, the hem of the top, the sleeve openings and the hem of the skirt.

6. Draw the bow with the knot in the center and add pleats to the skirt. The top should just skim the upper part of the skirt.

7. Draw in the hands and add details such as the socks and shoes. Drawing the tongue of the shoes is the key element to include.

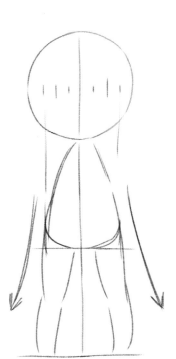

In a pose where the legs are apart and the figure is standing firmly upright, visualize a triangle shape from the body down to the ankles.

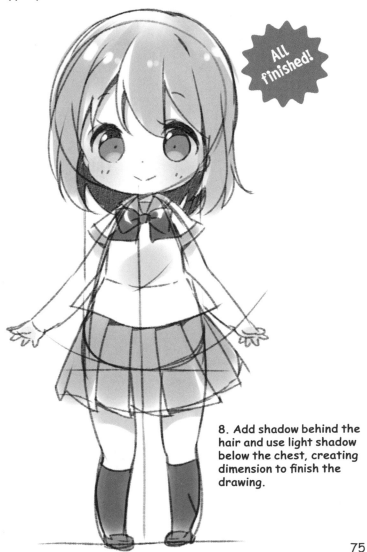

ALL finished!

8. Add shadow behind the hair and use light shadow below the chest, creating dimension to finish the drawing.

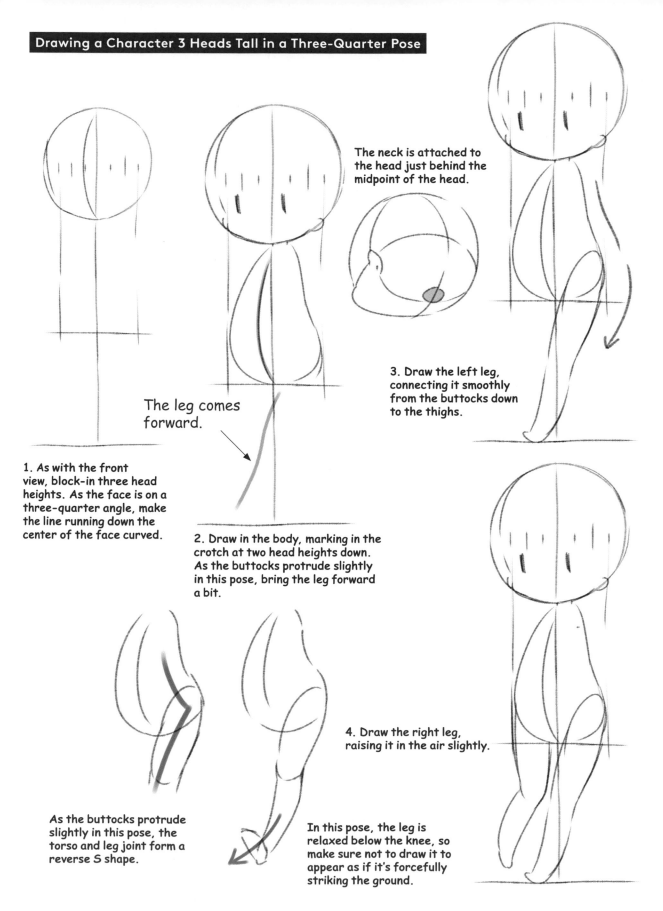

The neck is attached to the head just behind the midpoint of the head.

The leg comes forward.

3. Draw the left leg, connecting it smoothly from the buttocks down to the thighs.

1. As with the front view, block-in three head heights. As the face is on a three-quarter angle, make the line running down the center of the face curved.

2. Draw in the body, marking in the crotch at two head heights down. As the buttocks protrude slightly in this pose, bring the leg forward a bit.

4. Draw the right leg, raising it in the air slightly.

As the buttocks protrude slightly in this pose, the torso and leg joint form a reverse S shape.

In this pose, the leg is relaxed below the knee, so make sure not to draw it to appear as if it's forcefully striking the ground.

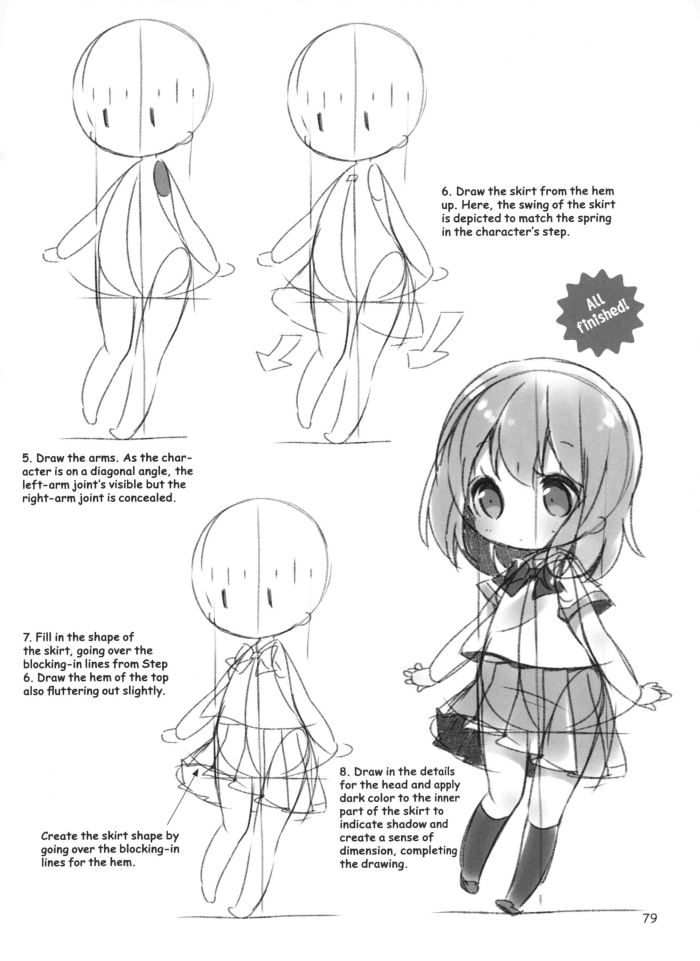

6. Draw the skirt from the hem up. Here, the swing of the skirt is depicted to match the spring in the character's step.

All finished!

5. Draw the arms. As the character is on a diagonal angle, the left-arm joint's visible but the right-arm joint is concealed.

7. Fill in the shape of the skirt, going over the blocking-in lines from Step 6. Draw the hem of the top also fluttering out slightly.

Create the skirt shape by going over the blocking-in lines for the hem.

8. Draw in the details for the head and apply dark color to the inner part of the skirt to indicate shadow and create a sense of dimension, completing the drawing.

79

DISTINGUISHING BETWEEN CHARACTERS 2 AND 3 HEADS TALL

Let's take a look at characters in various outfits and poses. Drawing figures 2 heads tall so they're easily distinguished from chibi that are 3 heads tall allows the same character to take on different qualities and levels of appeal.

BRIDE

This happy bride is enveloped in her dress. Her demure, elegant look suits a figure 3 heads tall which lends itself to detailed expression. On the other hand, the character 2 heads tall adopts a mascot-like cuteness.

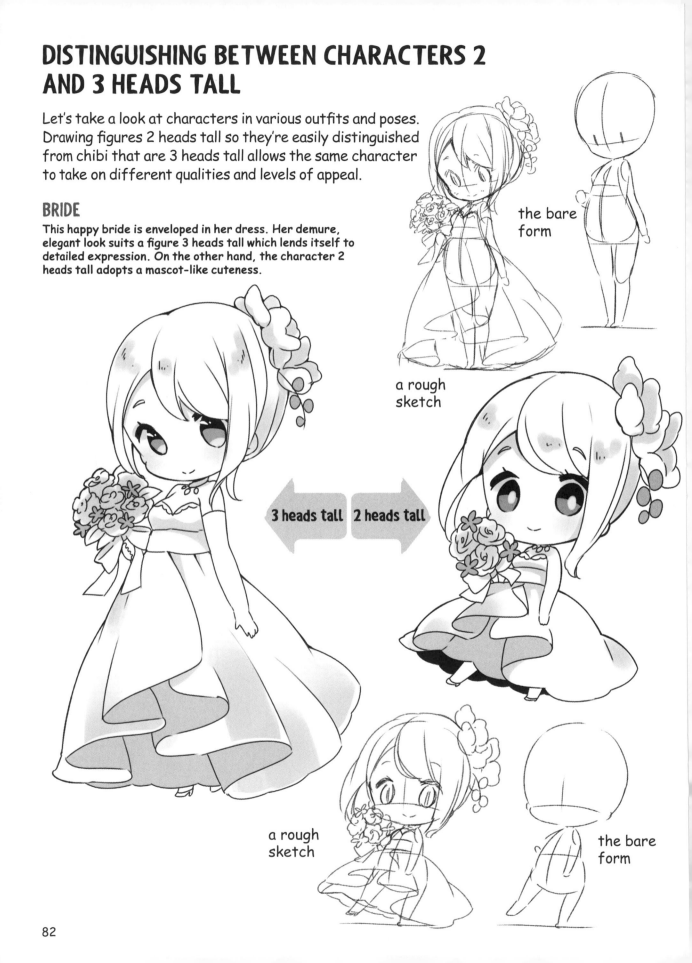

the bare form

a rough sketch

3 heads tall 2 heads tall

a rough sketch

the bare form

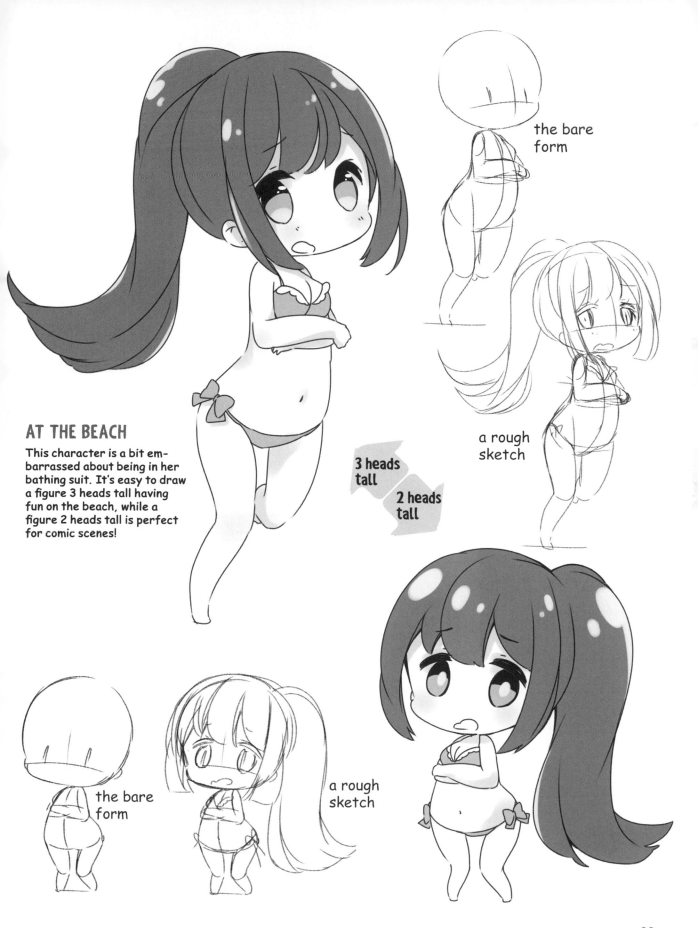

AT THE BEACH

This character is a bit embarrassed about being in her bathing suit. It's easy to draw a figure 3 heads tall having fun on the beach, while a figure 2 heads tall is perfect for comic scenes!

the bare form

a rough sketch

3 heads tall

2 heads tall

a rough sketch

the bare form

a rough sketch

ON THE SHY SIDE

This chibi character is a bit of an introvert, indicated by the way she's posed gripping her notebook tightly. The hat is one of her most attractive features, make it big so it stands out.

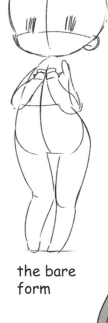

the bare form

a rough sketch

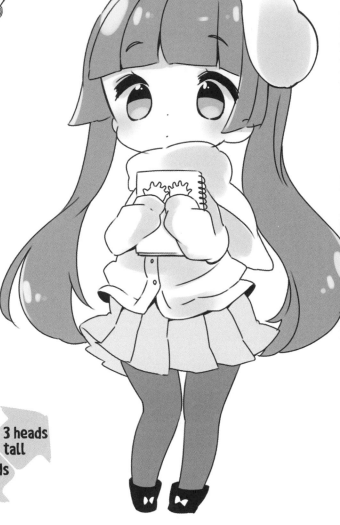

3 heads tall

2 heads tall

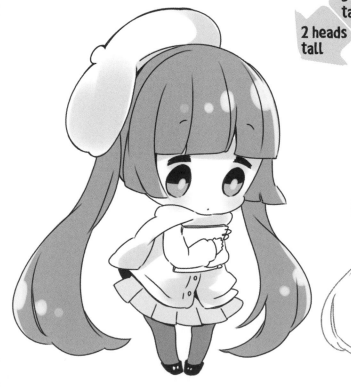

a rough sketch

the bare form

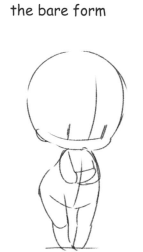

CAT-EARED CHARACTER

The cat ears say a lot about this vivacious character. Her elbows bent in a cat pose appear difficult to capture in a figure with a low head-to-body ratio, but skillfully drawing the folded arms makes it possible.

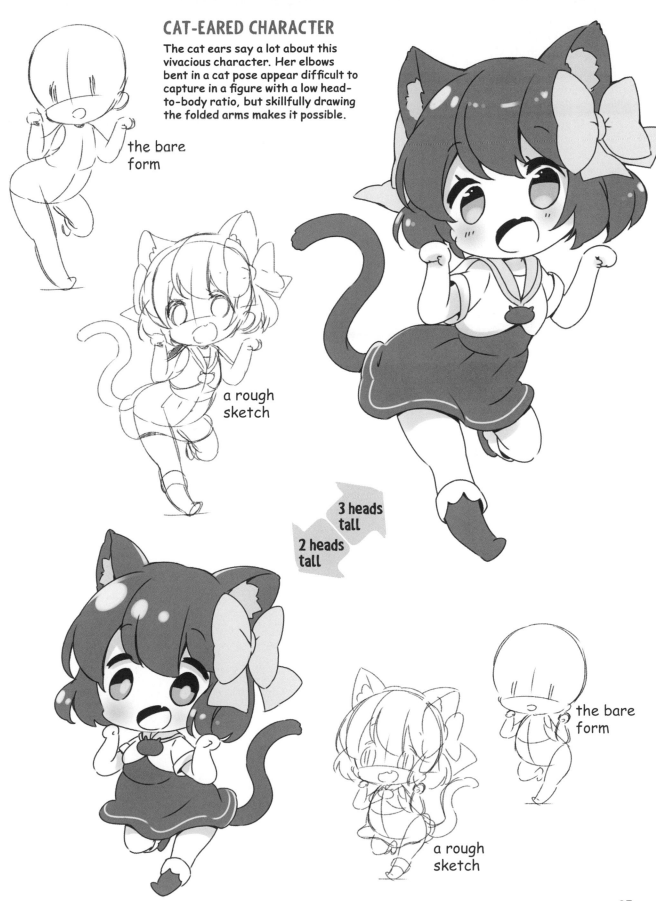

the bare form

a rough sketch

3 heads tall

2 heads tall

a rough sketch

the bare form

85

DOWN TO EARTH

This character prefers running around in pants to wearing a skirt. The length of the arms is different depending on the head-to-body ratio, and the difference in how the right hand is rendered is one specific area to pay attention to. When raising a hand in greeting, it's necessary for the figure 2 heads tall to raise it higher than for the taller figure.

the bare form

a rough sketch

3 heads tall

2 heads tall

a rough sketch

the bare form

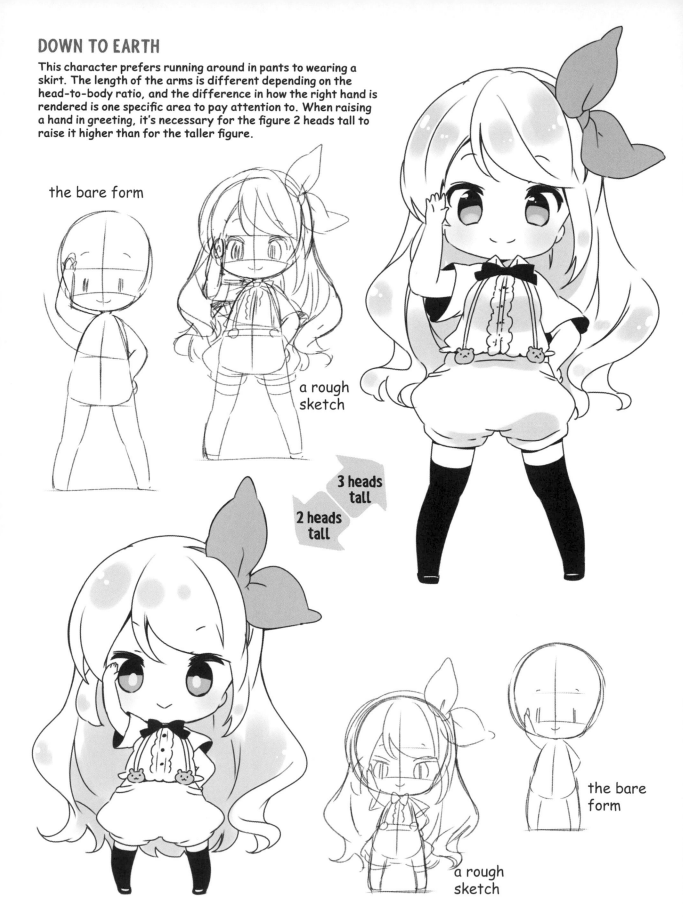

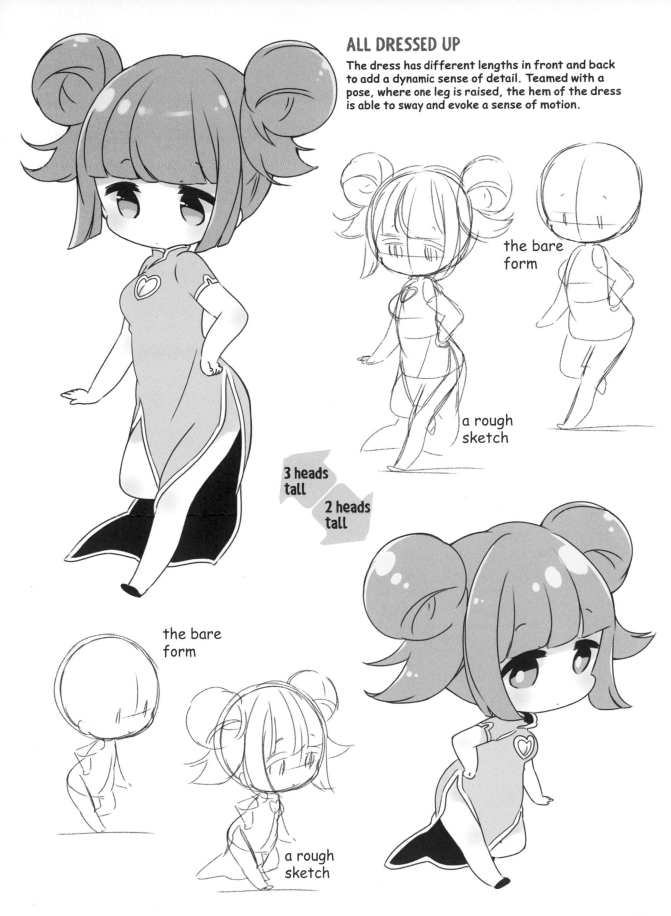

ALL DRESSED UP

The dress has different lengths in front and back to add a dynamic sense of detail. Teamed with a pose, where one leg is raised, the hem of the dress is able to sway and evoke a sense of motion.

the bare form

a rough sketch

3 heads tall

2 heads tall

the bare form

a rough sketch

ALL FRILLS

This frilly fashion offers yet another chibi costuming choice. Note how the frills are drawn differently depending on the head-to-body ratio.

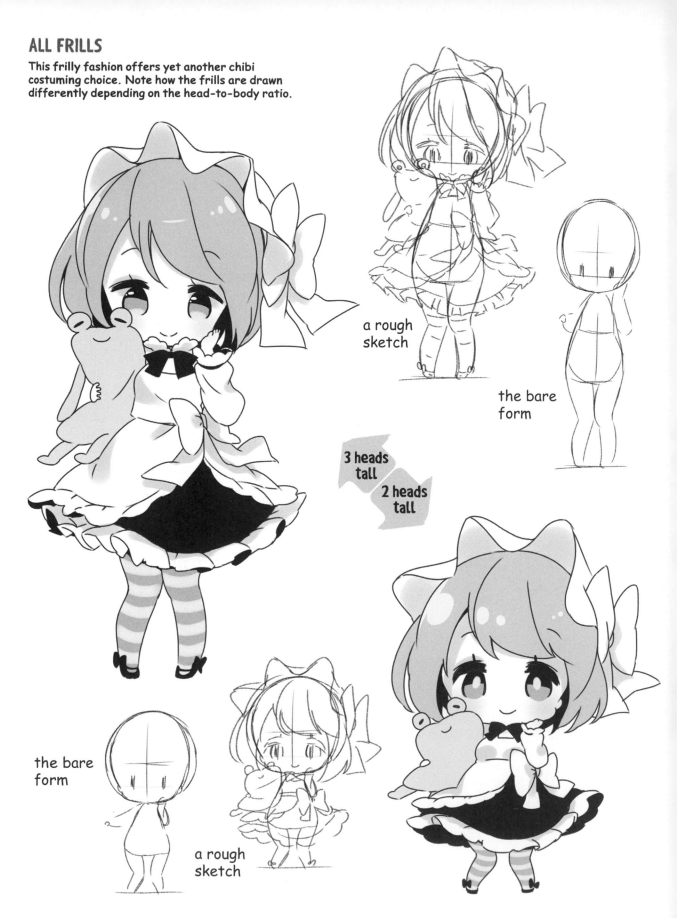

a rough sketch

the bare form

3 heads tall

2 heads tall

the bare form

a rough sketch

Drawing Chibi Faces

Mini characters have huge faces, so the way they're drawn determines how successful—and adorable—your final result it. When approaching the face, consider the balance of the eyes and nose, as well as the position of the mouth, making sure they suit each head-to-body ratio.

4

BALANCE OF THE FACE FOR A CHARACTER 2.5 HEADS TALL

Once you properly understand the position and size of each facial part for a figure 2.5 heads tall, you'll be able to consistently draw a cute expression.

A Line Beneath the Eyes

Draw a horizontal line beneath the eyes to use as a standard line from which to draw the facial outline. For a figure 2.5 heads tall, divide the head into six sections and position the line in the section first from the bottom.

▶▶▶ Proportions of the Facial Parts

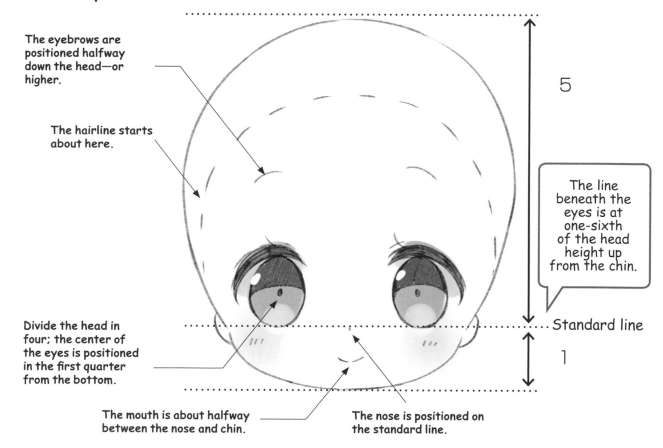

The eyebrows are positioned halfway down the head—or higher.

The hairline starts about here.

5

The line beneath the eyes is at one-sixth of the head height up from the chin.

Standard line

1

Divide the head in four; the center of the eyes is positioned in the first quarter from the bottom.

The mouth is about halfway between the nose and chin.

The nose is positioned on the standard line.

▶▶▶ Position of the Eyes

For open eyes

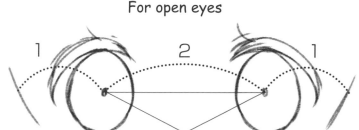

1 2 1

Spacing the eyes far apart creates an appealing look. Make the intervals from facial outline to eye, from eye to eye and from eye to facial outline 1:2:1.

The position of the eyes changes depending on the way they're closed.

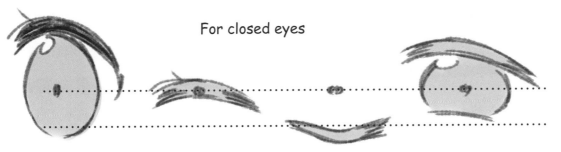

For closed eyes

When the eyes are closed from smiling broadly, use a curve to draw them with its peak in the center of the eye.

For a sleeping character, draw a curve with the ends up below the position of the eyes.

When the eyes are only slightly closed from smiling, the center of the eyes doesn't change, but the upper and lower lids draw closer to the center.

▶▶▶ Variations on Expressions Caused by the Eyes

center of the eye

Smiling broadly

Sleeping

Smiling

When the figure is seen from overhead, it would seem that the eyelids would be drawn using a curve with the ends up, but to express a smile, distort the curve, with the ends down.

This example shows the figure seen from below with the eyes slightly narrowed.

When working out the shape of a face, Points 1 through 6 in the diagram at right are key. Once you've grasped these, you won't have problems such as the face becoming too flat, too long or not working out the way you initially had in mind.

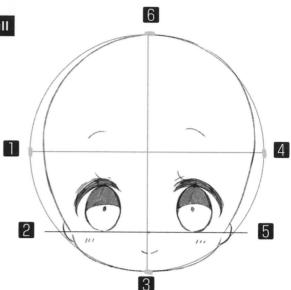

▶▶▶ Step by Step: Blocking-In

1. Let's try drawing a circle for blocking-in the face, starting with a cross. Draw the cross and mark in the radius at several points.

2. Draw a circle by connecting the radius marks.

3. If you're not good at drawing a well-balanced circle, this method is convenient.

▶▶▶ Step by Step: Drawing the Facial Outline and the Ears

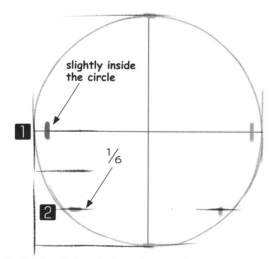

slightly inside the circle

1/6

1. Mark in Points 1 through 6. Make a mark slightly inside the left of the circle for 1 and mark one-sixth of the way up the face for Point 2.

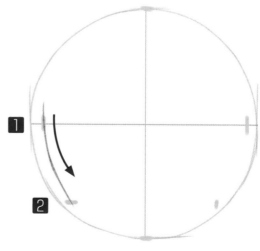

2. Using a smooth curve, draw a line through 1 and 2 using two strokes of the pen.

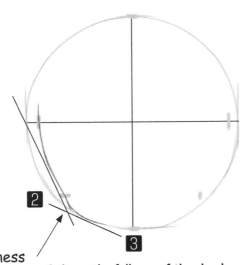

fullness

3. Draw the fullness of the cheeks starting from Point 2. Draw as if bringing the line down and turning at the point where it hits the blocking-in line, as if aiming for Point 3.

Take A Closer Look

For the cheeks, smoothness is everything!

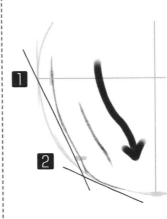

Rather than connecting 1 and 2, draw a long, smooth line forming an S-shaped curve through the points. If you use short lines, Point 2 will be exaggeratedly flat and it won't be possible to create smooth cheeks.

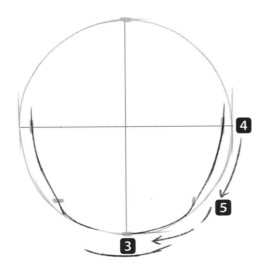

4. In the same way, make a smooth line from 4 to 5 to draw the facial outline. Make sure the section at 3 doesn't form a point.

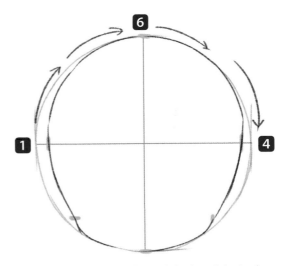

5. Draw curved lines through 1, 6 and 4—in that order—to form the outline of the head.

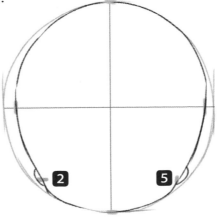

6. Draw the ears as if they're straddling or centered on Points 2 and 5.

▶▶▶ Step by Step: Determining the Positions of the Nose, Eyes and Mouth

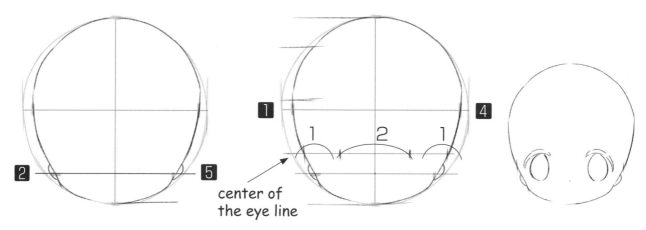

center of
the eye line

1. Draw a line connecting Points 2 and 5 and use it as the standard line. The nose is positioned at this height.

2. Determine the position of the center of the eyes. This will be roughly halfway the length of the line that passes down to the chin through the line from Points 1 through 4. When the facial outline is divided into four equal parts, the centers of the eyes will be at the positions between 1 and 2 on the center of the eye line.

If you don't work out in advance where the centers of the eyes are, the characters' gazes will be unstable and it won't be possible to tell where they're looking.

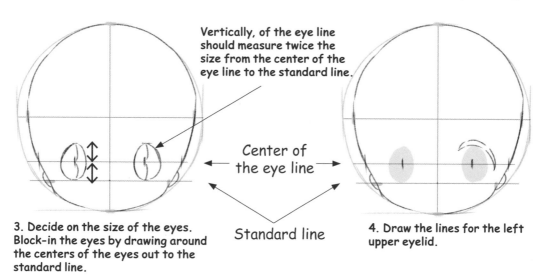

Vertically, of the eye line should measure twice the size from the center of the eye line to the standard line.

Center of
the eye line

Standard line

3. Decide on the size of the eyes. Block-in the eyes by drawing around the centers of the eyes out to the standard line.

4. Draw the lines for the left upper eyelid.

Take A Closer Look

Drawing the Upper Eyelid: Three Different Ways

Using multiple lines to create the upper eyelid makes it hard to produce a clear form. Use three strokes of the pen to draw the head, peak and tail of the eyebrow.

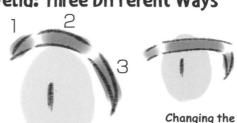

Changing the angle of the three lines allows you to draw different types of eyes, such as slanted or drooping ones.

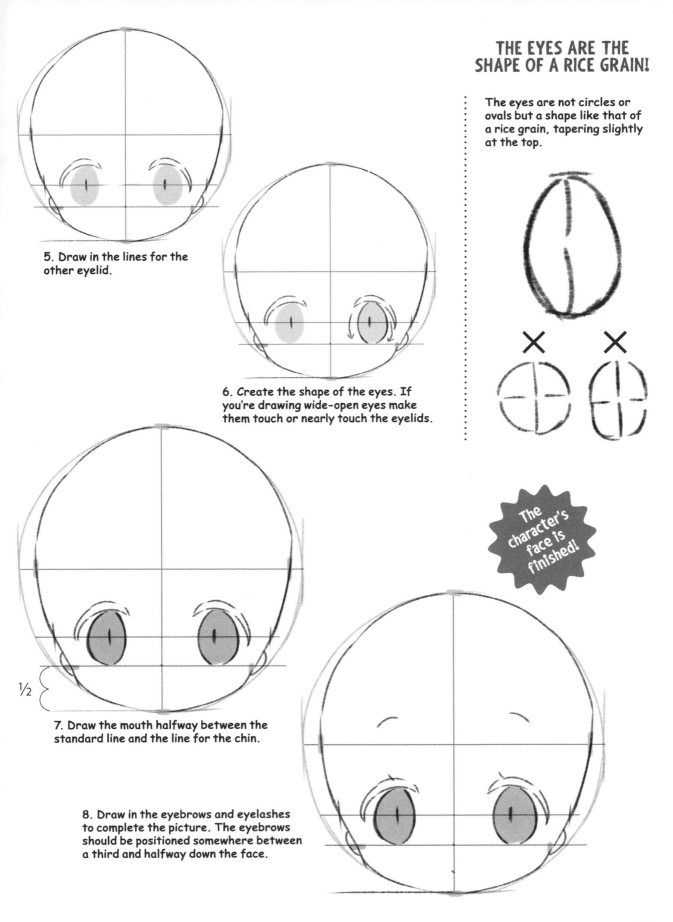

THE EYES ARE THE SHAPE OF A RICE GRAIN!

The eyes are not circles or ovals but a shape like that of a rice grain, tapering slightly at the top.

5. Draw in the lines for the other eyelid.

6. Create the shape of the eyes. If you're drawing wide-open eyes make them touch or nearly touch the eyelids.

The character's face is finished!

½

7. Draw the mouth halfway between the standard line and the line for the chin.

8. Draw in the eyebrows and eyelashes to complete the picture. The eyebrows should be positioned somewhere between a third and halfway down the face.

Drawing a Face for a Character 3 Heads Tall

The key points for balance are different from those for a figure 2.5 heads tall. The standard line joining Points 2 and 5 is slightly higher. The facial outline for the jaw is just barely more defined than for that of a character 2.5 heads tall.

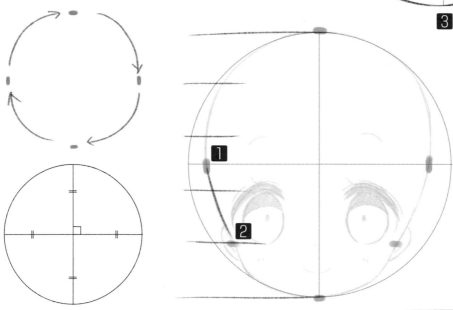

▶▶▶ **Step by Step: Drawing the Facial Outline and the Ears**

1. Follow the steps on page 94 to draw a circle.

2. Divide the height of the face into five equal parts and mark them in. Mark in Point 2 at one-fifth the distance up the face. Use one stroke of the pen to make a line starting at 1 and heading toward 2.

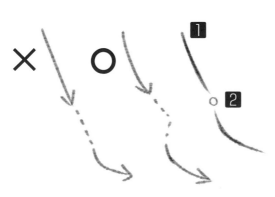

3. Make sure the line from Point 1 to Point 2 isn't straight. Draw a smooth curved line going toward 2, then create the fullness of the cheeks below that.

4. Draw a line from Point 2 to Point 3. Make the line for the chin follow the blocking-in for the circle.

5. Draw the line below the chin to also follow the circle's line.

6. Draw the outline for the opposite side by connecting Points 4, 5 and 3, in that order.

Take A Closer Look

No Pointy Chins!

If you're new to drawing chibi characters, you might have a tendency to give your figures pointed chins. The chin's an important element for expressing a mini character's softness and appeal, so round it out.

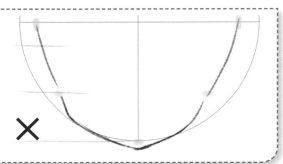

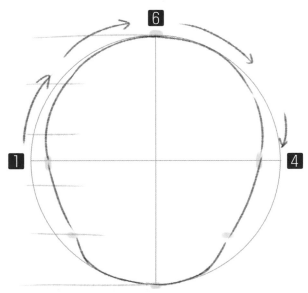

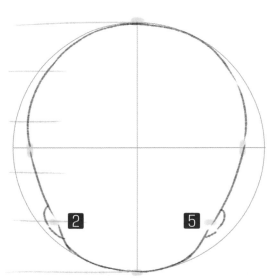

7. Create the rest of the outline by joining Points 1, 6 and 4, in that order. Not drawing in this section tends to lead to the head flattening out or the ratios and proportions changing. Make sure to draw the outline so it passes through Point 6.

8. Draw the ears at Points 2 and 5.

▶▶▶ Step by Step: Determining the Positions of the Nose, Eyes and Mouth

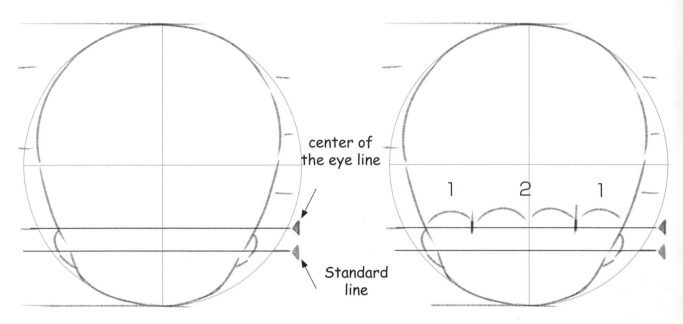

center of
the eye line

Standard
line

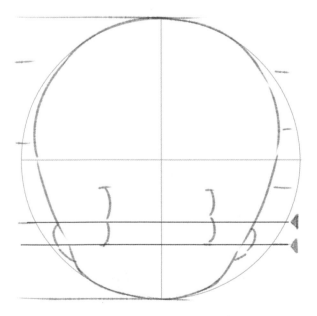

1. Draw a line connecting Points 2 and 5 and use it as the standard line. Then add the line for the center of the eyes above it. The center of eye line should be slightly higher than one-quarter of the way up the face.

2. Determine the position of the eyes. Divide the face into four equal widths and space the intervals from the facial outline to each of the eyes and the gap between the eyes at the ratio 1:2:1.

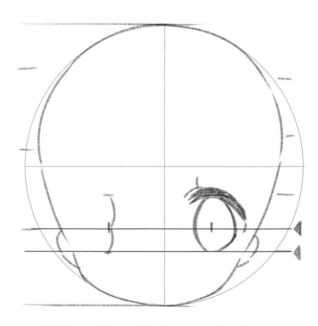

3. Double the height from the standard line to the center of eye line to work out the size of the eyes.

4. Create shapes like rice grains for the eyes and draw in the upper eyelids.

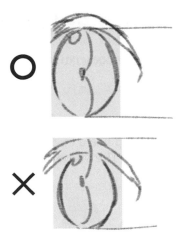

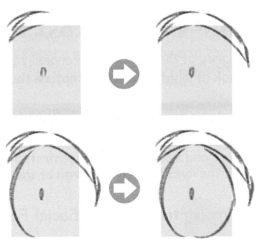

5. The size of the eye itself should be double the height from the standard line to the center of eye line. Be careful not to include the eyelid in this measurement.

6. Draw the left eye. Add in the upper eyelid, starting with the inner corner and work out the shape of the eye, positioning it either touching the eyelid or slightly away from it.

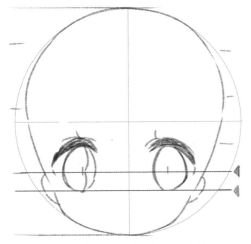

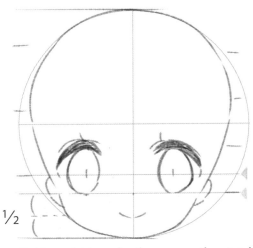

7. Draw in both eyes. Check carefully to make sure they're symmetrical.

8. Use a dot to make the nose on the standard line. Draw in the mouth halfway between the standard line and the chin.

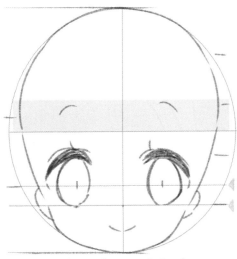

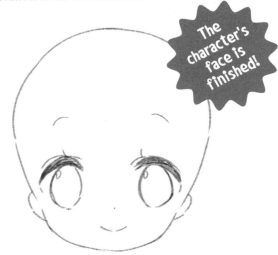

The character's face is finished!

9. Draw in the eyebrows, aiming for an area a bit higher than halfway up the face.

10. Erase the guide marks and adjust the overall shape to complete the bare form.

For figures of this head-to-body ratio, the chin is extremely compressed. Visualize a flat plate in order to create the facial outline.

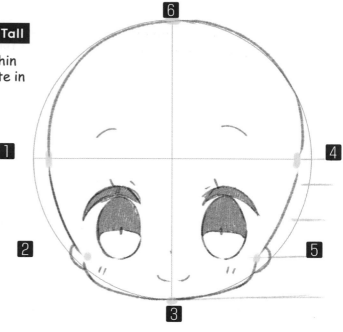

▶▶▶ **Step by Step: Drawing the Facial Outline and the Ears**

1. Draw a circle using the steps on page 94.

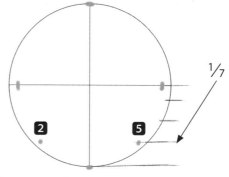

2. Determine the positions of Points 1 through 6. The standard line (the line joining Points 2 and 5) should be one-seventh of the way up the face.

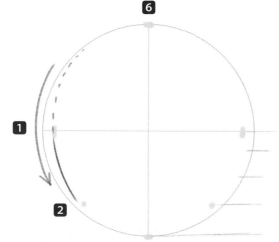

3. Draw the outline, heading toward the standard line. Make sure the line joining Points 1 and 2 is not straight. Draw as if it is an extension of the curved line that starts at Point 6.

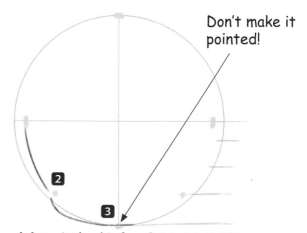

Don't make it pointed!

4. Draw in the chin from Points 2 to 3. This is the chubby fullness of the cheeks, so be sure to use a soft curved line.

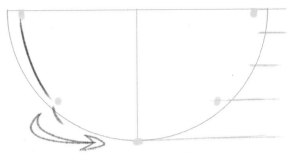

5. The cheeks are very small, but make sure they're rounded nonetheless.

Don't shave off this part!

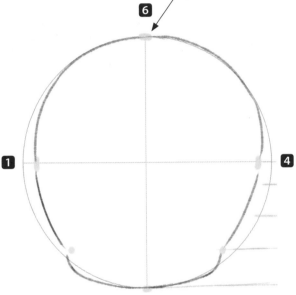

7. Block-in the head from Points 1 to 6 and then to 4. Make sure the top of the head doesn't get taken off by extending the line through Point 6.

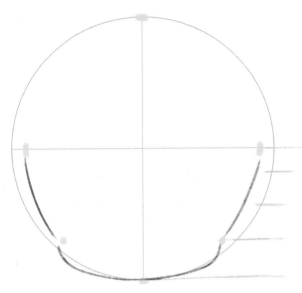

6. Draw in the outline on the opposite side.

Take A Closer Look

The chin is nearly completely flat!

The chin should appear as if the bottom of a circle has been shaved off. It's important not to make Point 3 too pointed, but rather a line that curves slightly but is nearly completely flat.

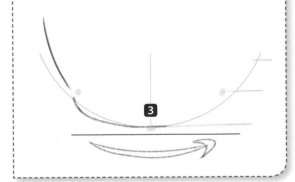

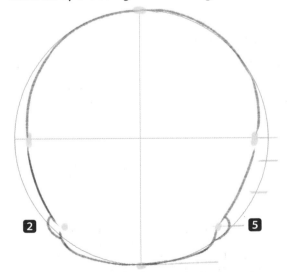

8. Mark in the shape of the ears to fit in snugly at Points 2 and 5.

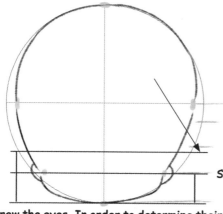

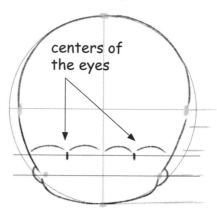

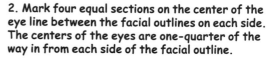

center of the
eye line

standard line

centers of
the eyes

1. Draw the eyes. In order to determine their position, divide the head vertically into four equal sections. Draw in a guide line one-quarter of the way up the face. This is the center of the eye line.

2. Mark four equal sections on the center of the eye line between the facial outlines on each side. The centers of the eyes are one-quarter of the way in from each side of the facial outline.

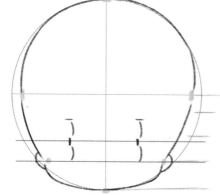

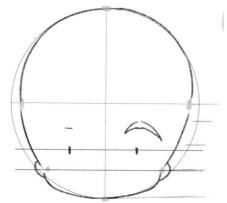

3. Block-in double the height from the centers of the eyes to the standard line. This is the size of the eyes.

4. Draw short, thick eyelids and draw the eyes in underneath.

Take A Closer Look

Characters 2 heads tall have short upper eyelids!

Giving short upper eyelids to characters 2 heads tall highlights the advantages and appeal of this particular head-to-body ratio. Indicate the eyelids in one short thick line or add a line at the outer corners of the eyes as well.

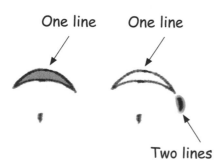

One line One line

Two lines

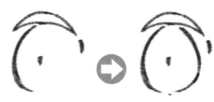

The eye should be as wide as the short eyelid or slightly narrower. Draw the inner curve of the eye first, then an outer curve that slightly swells at the base.

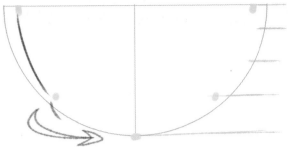

5. The cheeks are very small, but make sure they're rounded nonetheless.

Don't shave off this part!

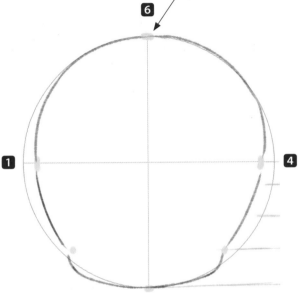

7. Block-in the head from Points 1 to 6 and then to 4. Make sure the top of the head doesn't get taken off by extending the line through Point 6.

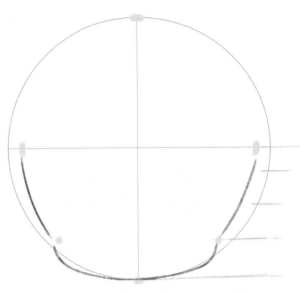

6. Draw in the outline on the opposite side.

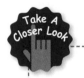

Take A Closer Look

The chin is nearly completely flat!

The chin should appear as if the bottom of a circle has been shaved off. It's important not to make Point 3 too pointed, but rather a line that curves slightly but is nearly completely flat.

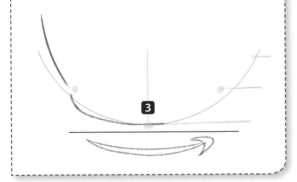

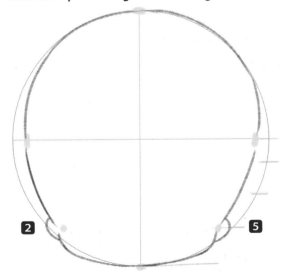

8. Mark in the shape of the ears to fit in snugly at Points 2 and 5.

▶ ▶ ▶ Step by Step: Determining the Positions of the Nose, Eyes and Mouth

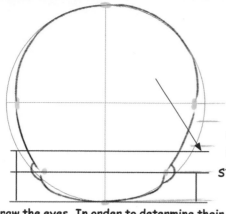

center of the
eye line
standard line

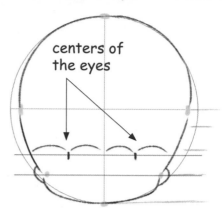

centers of
the eyes

1. Draw the eyes. In order to determine their position, divide the head vertically into four equal sections. Draw in a guide line one-quarter of the way up the face. This is the center of the eye line.

2. Mark four equal sections on the center of the eye line between the facial outlines on each side. The centers of the eyes are one-quarter of the way in from each side of the facial outline.

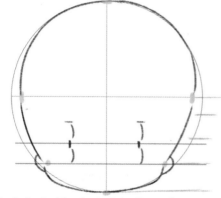

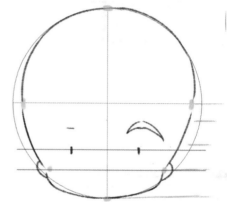

3. Block-in double the height from the centers of the eyes to the standard line. This is the size of the eyes.

4. Draw short, thick eyelids and draw the eyes in underneath.

Take A Closer Look

Characters 2 heads tall have short upper eyelids!

Giving short upper eyelids to characters 2 heads tall highlights the advantages and appeal of this particular head-to-body ratio. Indicate the eyelids in one short thick line or add a line at the outer corners of the eyes as well.

One line One line

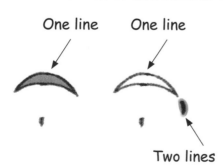

Two lines

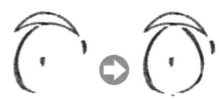

The eye should be as wide as the short eyelid or slightly narrower. Draw the inner curve of the eye first, then an outer curve that slightly swells at the base.

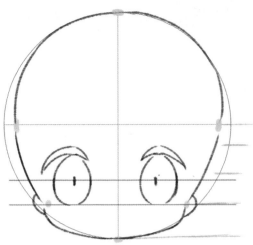

5. Draw both eyes. Think of an almond as you're shaping them.

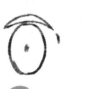

almond-shaped elliptical circular

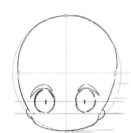

Elliptical eyes are cute too, but circular eyes might be a bit offputting.

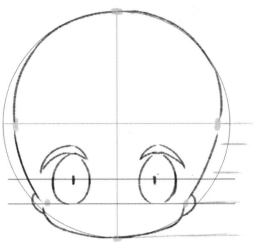

standard line

position of the nose

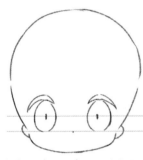

Positioning the nose on the standard line won't look strange, but it won't fully enhance a character's chibi appeal.

6. Decide on the position of the nose. At this head-to-body ratio, the nose can be omitted, but if you do draw it in, positioning it slightly above the standard line is best.

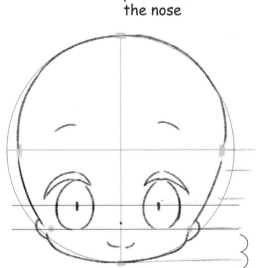

7. Draw in the eyebrows slightly higher than halfway up the face and the mouth halfway between the chin and the standard line.

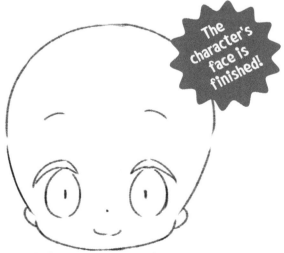

The character's face is finished!

8. Get rid of any unnecessary elements to complete the exaggerated face of a character 2 heads tall.

DRAWING DIFFERENT FACIAL FEATURES

Now let's look at drawing facial features in order to distinguish between characters. We'll look not only at different ways of drawing depending on head-to-body ratio, but also how to draw facial parts differently to suit various character types or personalities.

Drawing the Facial Outline and Cheeks

As chibi characters have extremely large eyes, you need to create a suitable facial outline that can accommodate them. Use the line beneath the eyes as the point from which to round out the face.

▶▶▶ Cheeks That Suit a Chibi Character

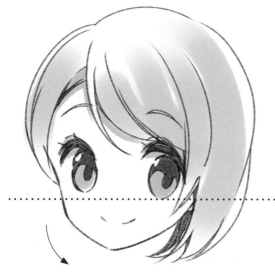

On a realistically drawn human face, the area around the eyes is sunken. For a more naturalistic character, it's fine to draw the rounding of the cheeks starting at the position of the eyes . . .

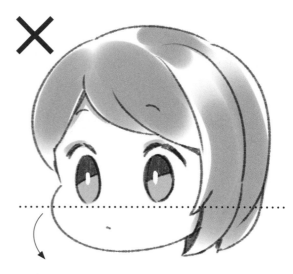

On a chibi face, the cheeks are one of the least realistic features. Plump, rounded and jowl-like, they add to the fullness of the chibi face.

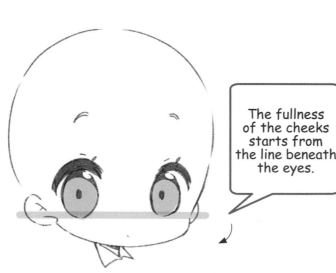

The fullness of the cheeks starts from the line beneath the eyes.

When drawing a character's cheeks, ignore the bone structure and create fullness from the line beneath the large eyes.

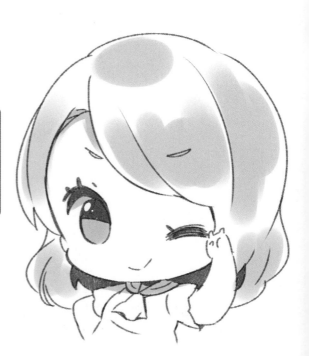

▶▶▶ Variations on Facial Outlines in a Figure 2 Heads Tall

Characters' facial outlines can be varied for different looks. Regardless of the character type, the fullness of the cheeks begins at the standard line. This example uses a character 2 heads tall.

SLIM TYPE

Only the slightest rounding of the cheeks is drawn in from the standard line.

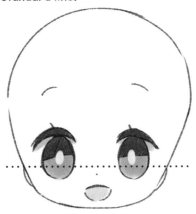

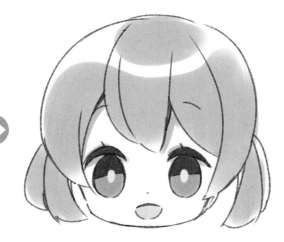

POINTED TYPE

Draw the cheeks as if the fullness is bursting out from the standard line.

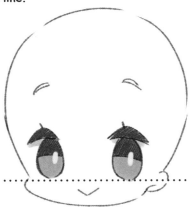

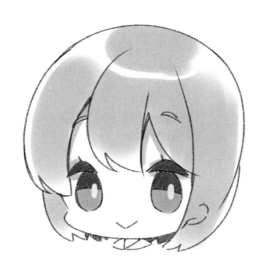

CHUBBY TYPE

Use a soft curve to create the fullness of the cheeks from the standard line.

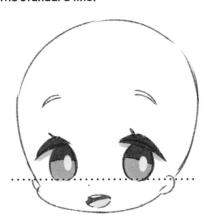

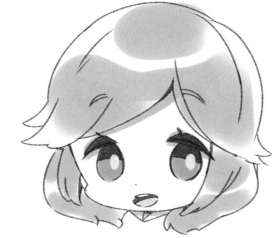

111

Drawing the Mouth

Wide open and laughing or shouting, pursed and pouting. The mouth moves in a multitude of ways to reflect emotion. There are also ways to draw mouths specifically to suit mini characters.

▶▶▶ Using Distortion

Omitting the details of a more realistically drawn mouth and creating a shape similar to a circle produces a particularly chibi-like mouth. For a closed mouth, a strong curve is the best choice.

These are examples of the mouth for a distressed or troubled character. For a realistic-looking character, the bone in the chin stops the mouth from opening out onto the facial outline. But for a chibi character, the mouth can practically touch the facial outline.

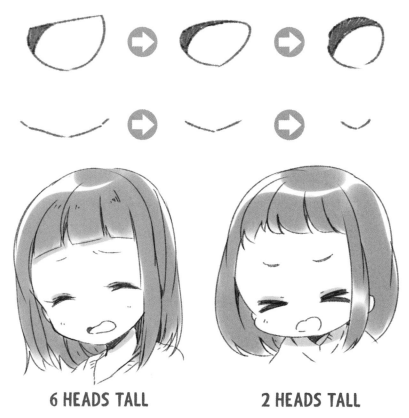

6 HEADS TALL **2 HEADS TALL**

▶▶▶ Expressions Unique to Chibi Characters

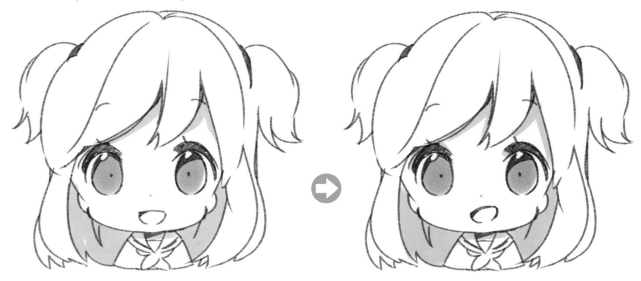

Draw a simple, bowl-shaped mouth, but tilt it about 15 degrees to emphasize the character's emotions.

This example shows how a happy expression on a character 6 heads tall is adapted and distorted for a character 2 heads tall. It's fine to leave it like this, but the character will look only moderately happy. Tilting the mouth emphasizes the happiness of the initial character and better conveys the emotion.

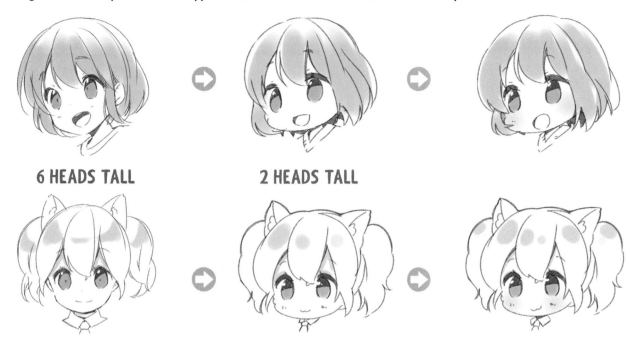

6 HEADS TALL **2 HEADS TALL**

This example shows a closed mouth. Even drawing it as a flat W shape makes for an appealing look, but tilting it highlights the charming qualities that characterize a chibi character.

▶▶▶ Various Mouth Shapes for Figures 2 Heads Tall

A closed mouth depicted with a W shape makes a more memorable impression than a plain U-shaped mouth.

A mouth drawn with a wavy line with downturned ends conveys a sense of complicated emotions or bewilderment.

Pursed lips are another chibi option. Use a regular or reverse 3 to create this look.

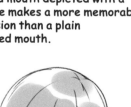

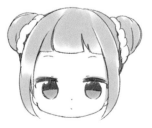

Here, the mouth forms a circle from surprise. The nearly perfectly circular mouth conveys the sense of strong surprise.

Compared with a U-shaped mouth, a V-shaped mouth gives the impression that the lips are tightly closed.

A mouth expressed with a dot works well as an expression of frustration or irritation.

Drawing Hair As the hairstyle helps to express a character's tastes and personality, it's important to get it right. Exaggerate or simplify the hair to portray each figure differently.

▶▶▶ Expressions Unique to Chibi Characters

For more realistically drawn characters (those 6 heads tall), draw smoothly flowing hair in detail. For chibi characters, however, detailed hair results in an awkward look. Leave out the details of flowing or flyaway hair, creating broad hanks or locks of hair instead.

6 HEADS TALL

2.5 HEADS TALL

Use a fluid S-shaped curve to draw hair for a character 6 heads tall and add detailed nuances such as flyaway strands.

Let's see what happens when the same character is 2.5 heads tall. For a chibi character, don't add complicated curved lines, but rather think of the hair flowing together in a single mass. Basically, several large locks of hair should overlap to create the overall style, but it's fine to add in more detailed pieces here and there.

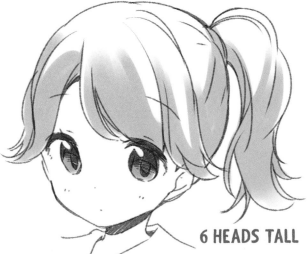

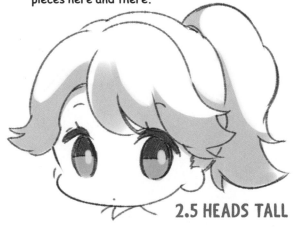

6 HEADS TALL

2.5 HEADS TALL

When a character has hair flips or curls at the ends or something unique or specific that defines her hairstyle, don't omit it, but rather emphasize it. It's an important element for showing that even at a different head-to-body ratio, this is the same character.

▶▶▶ Differences in the Hair by Head-to-Body Ratio

Even for the same chibi character, draw the details of the hair differently depending on the head-to-body ratio.

fine pieces

even finer pieces

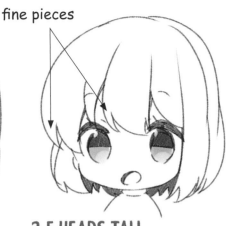

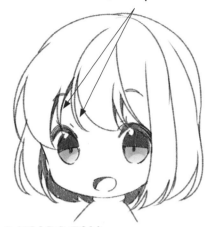

2 HEADS TALL

Roughly divide the hair into broad pieces to draw it.

2.5 HEADS TALL

Add in a few fine pieces to the larger locks of hair.

3 HEADS TALL

Add fine pieces between larger locks of hair and detailed nuances that indicate the hair's flow the key is to not make it too detailed.

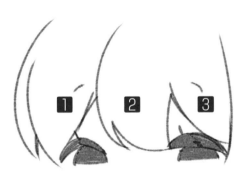

fine strands

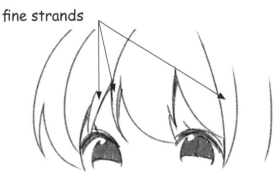

Create about three pieces for a chibi character's bangs, avoiding the eyes. This example is for a character 2 heads tall.

For characters 2.5 or 3 heads tall, add in fine pieces of hair between the three larger locks.

▶▶▶ Step by Step: Drawing the Hair

Divide hair into three blocks—the bangs, the hair hanging at the sides and at the back—in order to create the overall shape.

Add pieces crossing over the top of each block as if to cover it. Add small splits at the ends.

It comes down to individual taste, but don't make the hair too detailed. Chibi styles keep it simple.

MAKE SURE THE FACE MATCHES THE HEAD-TO-BODY RATIO

So far we've looked at how to draw faces that suit each head-to-body ratio. To create appealing chibi characters, striking the right balance between the face and body is crucial.

Avoiding Faces That Don't Match the Head-Body Ratio

The faces of characters 3 heads tall can work on figures 4 to 6 heads tall too. However, they don't match characters 2.5 or 2 heads tall. It's important of course to draw faces that suit each head-to-body ratio.

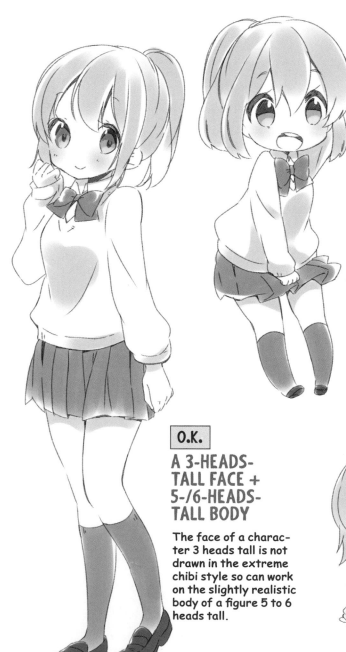

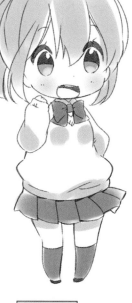

O.K.

3-HEADS-TALL FACE + 3-HEADS-TALL BODY

Naturally, the face for a figure 3 heads tall suits this head-to-body ratio best.

Not O.K.

3-HEADS-TALL FACE + 2.5-HEADS-TALL BODY

This doesn't look weird, exactly, but just a bit off-balance.

O.K.

A 3-HEADS-TALL FACE + 5-/6-HEADS-TALL BODY

The face of a character 3 heads tall is not drawn in the extreme chibi style so can work on the slightly realistic body of a figure 5 to 6 heads tall.

Not O.K.

3-HEADS-TALL FACE + 2-HEADS-TALL BODY

The body is small, so the grown-up face makes for an odd look.

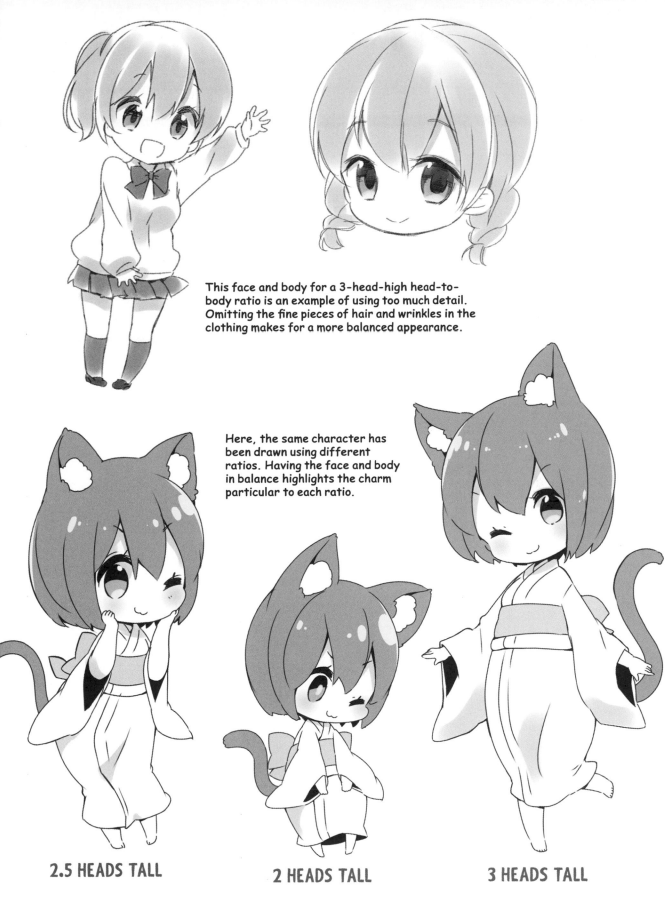

This face and body for a 3-head-high head-to-body ratio is an example of using too much detail. Omitting the fine pieces of hair and wrinkles in the clothing makes for a more balanced appearance.

Here, the same character has been drawn using different ratios. Having the face and body in balance highlights the charm particular to each ratio.

2.5 HEADS TALL

2 HEADS TALL

3 HEADS TALL

TRY DRAWING HEAD COVERINGS

As chibi characters have large heads, hats and head coverings with distinctive features such as cat ears suit them. Try to get the knack of drawing them.

Helmet

Try drawing a helmet on a character 2 heads tall.

Simply adding a helmet to the existing figure makes the head much bigger due to its thickness, making the head-to-body ratio appear closer to 1.8 than 2.

For drawings like these, fit the helmet to extend out from the head at about the same thickness as the hair to create a well-balanced look.

Cat ears

Decide which way the ears will point. There's no need for them to both point in the same direction.

Use soft, curved lines to create triangles to sketch in the overall shape.

Work out the position where the ears begin and draw the insides of the ears.

The figure viewed from the side. The natural position from which to extend the ears is halfway down the head.

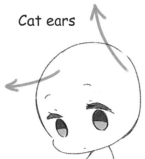

The figure viewed from above. The insides of the ears face forward, so keep this in mind when drawing them from other angles.

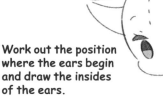

On a three-quarter angle, the ears appear to be connected to the back of the head.

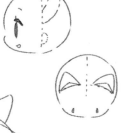

When drawing the character from the side, making the ears point backward can create an appealing look too.

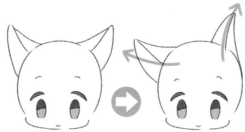

Symmetrical ears are fine, but making them asymmetrical adds an extra layer of refinement and distinction to your character.

Expressing Chibi Emotions

Faces beaming with joy, pinched in sadness or swelling up with rage. It's time for your chibi characters to express themselves and time for you to learn the techniques for bringing them to life through facial expressions and poses.

5

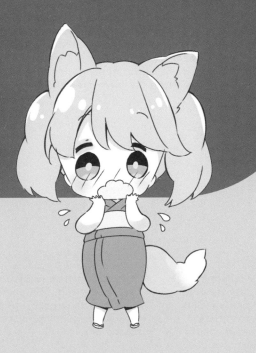

CONVEYING EMOTION THROUGH POSES AND EXPRESSIONS

Laughing, crying, getting excited, feeling shy. In order to draw chibi characters' emotions in a believably appealing way, try combining an overall body pose with the appropriate facial expression.

Understanding the Shape of the Face from Various Angles

When posing a character, the face will need to be depicted from various angles, other than just from the front. You will need to be develop a sense of dimensionality in order to be able to draw the face from various angles.

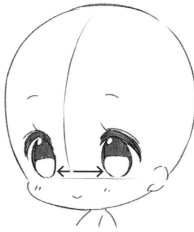

Three-Quarter
Pose

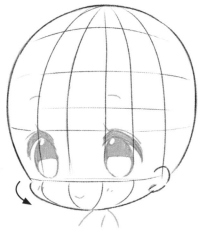

Take care when it comes to the distance from the eyes to the median line that runs down the center of the head. The eye closest to the viewer will appear farthest from the center.

This shows a chibi character's face viewed from below. Think of the front of the face as being flat in order to get an understanding of where the eyes are positioned.

Side view

Here, gridlines have been ruled on a face that's posed at a three-quarter angle. The rounding of the cheeks begins at the standard line running beneath the lower eyelids.

Eyes on this diagonal angle are shaped like almonds.

A flattened facial outline yields an odd look.

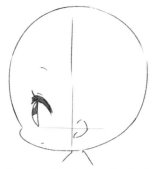

Compared with a realistically drawn character, the ears on a chibi character are quite low on the head. The fact that their noses don't protrude is also a defining characteristic.

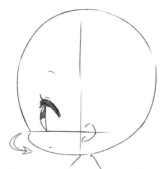

The facial outline swells out from the lower eyelid. It's not the shape of the mouth or nose, but rather a swelling or rounding unique to mini characters.

For eyes viewed from the side, keep the curve of the eyeball in mind and round out the eye.

Omitting the nose creates the appearance unique to chibi characters.

Angled bird's-eye view

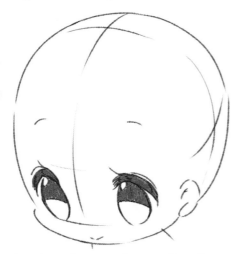

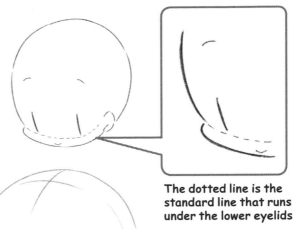

There's no change in the rounding of the cheeks starting at the line running beneath the lower eyelids.

The dotted line is the standard line that runs under the lower eyelids.

Getting an understanding of the standard line makes it easier to add expression.

Angled view from below

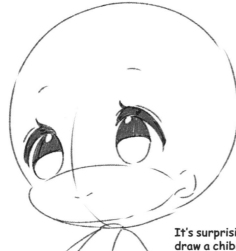

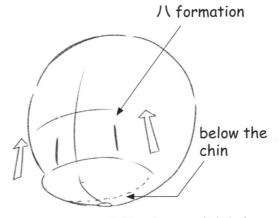

It's surprisingly difficult to draw a chibi character viewed from below. The trick is to firmly define the position.

ハ formation

below the chin

Making the eyes slightly form a ハ shape (with the tops of the eyes angling inward) creates the appearance of the face being viewed from below. Remember that the bottom of the chin is also visible from this angle.

The gray section is the area below the chin. For chibi characters, no dividing line is drawn between the front of the face and below the chin, so when viewed from below, the area below the mouth appears broad.

Broad below the mouth

Create an expression that suits the mini character's pose. The extreme expression that results from combining features—especially the ones coded below—suits chibi characters well.

▶▶▶ Example of Combining Features for Expression

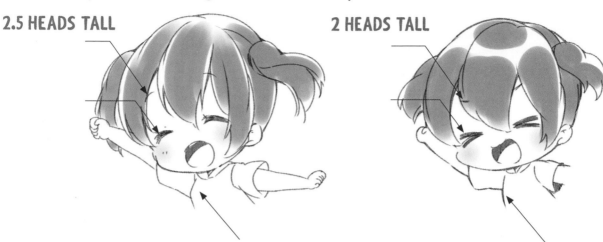

2.5 HEADS TALL

2 HEADS TALL

This example shows how expression has been formed by combining the eyebrows, eyes and mouth. Use whichever parts you like from the chart below to create any number of expressions.

Adding comical-style parts from the chart makes for a more extremely distorted expression.

	1	2	3	4	5
a = eyebrows					
b = eyes					
c = comical eyes					

	1	2	3	4	5	6
d = mouth						
e = comical mouths						

▶▶▶ Examples of Subtle Expressions

Even for chibi characters whose facial features are simple, it's possible to create detailed expressions with a tweak or two.

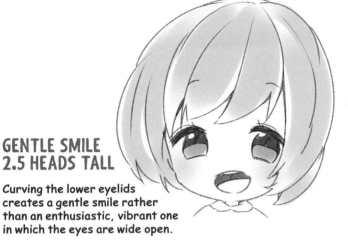

GENTLE SMILE 2.5 HEADS TALL

Curving the lower eyelids creates a gentle smile rather than an enthusiastic, vibrant one in which the eyes are wide open.

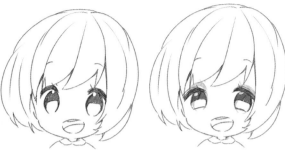

These drawings compare a smiling face with the eyes wide open to that of a gentle smile. The position of the upper eyelids is slightly lowered, and the eyes are narrowed.

SLEEPY EXPRESSION 2.5 HEADS TALL

Lowering the position of the eyelids a little as if the character is looking at the ground creates a sense of sleepiness. The eyes are not true circles but rather slightly flattened out.

These drawings compare an alert expression with a sleepy one. The upper eyelids are considerably lowered, as if the character could drift off to sleep at any moment.

The above examples are for figures 2.5 heads tall, but it's possible to create subtle expression for characters 2 heads tall in the same way.

2 HEADS TALL

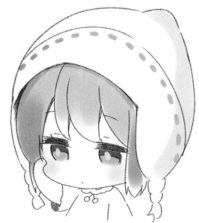

Draw the upper eyelids using short, thick lines and flatten the eyes even more.

Make the height of the eyes shorter here too, so that they're nearly square.

Simple Poses and More Difficult Poses

As chibi characters have short limbs, there are poses that are simple to express and others that are a bit more challenging. For more difficult poses, capture them using trompe l'oeil effects.

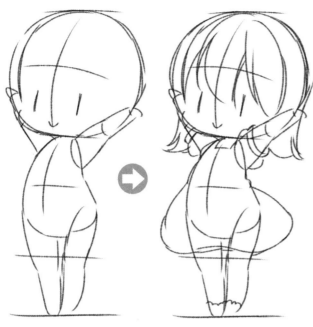

A pose with both arms lowered is simple. However, a pose in which both arms are raised is not actually possible as it would mean the arms hit the head. Here, the size of the head is ignored, and the arms are drawn flush with the head to create the look.

This pose shows the figure having fallen flat on the ground. In reality, the arm farthest away shouldn't be visible, but here the arm has been lengthened in order to create the look the pose requires.

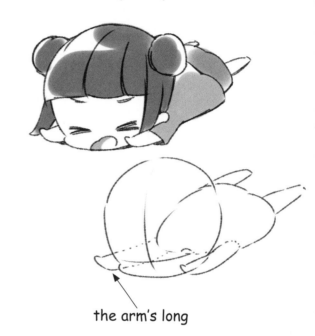

the arm's long

Ignoring the size of the stomach allows for the leg to move freely.

Drawing the character lying down is difficult too, as the size of the head means the body would be floating in air. Curve the neck to create poses like this.

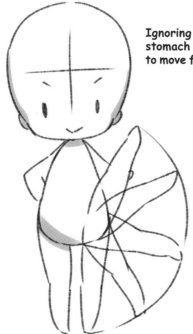

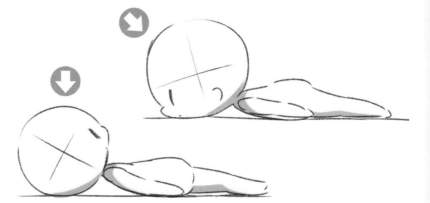

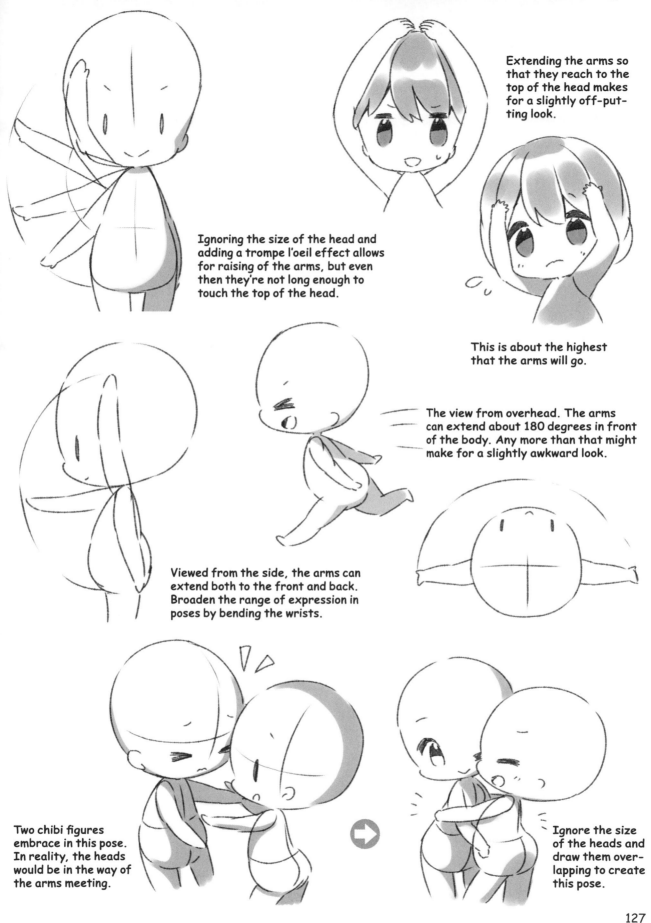

Extending the arms so that they reach to the top of the head makes for a slightly off-putting look.

Ignoring the size of the head and adding a trompe l'oeil effect allows for raising of the arms, but even then they're not long enough to touch the top of the head.

This is about the highest that the arms will go.

The view from overhead. The arms can extend about 180 degrees in front of the body. Any more than that might make for a slightly awkward look.

Viewed from the side, the arms can extend both to the front and back. Broaden the range of expression in poses by bending the wrists.

Two chibi figures embrace in this pose. In reality, the heads would be in the way of the arms meeting.

Ignore the size of the heads and draw them overlapping to create this pose.

127

CREATING EXPRESSIONS OF JOY AND HAPPINESS

Let's try expressing the various emotions of chibi characters, starting with those bursting with joy.

Happiness That Radiates Outward

Draw happiness as if it's emitting outward from the character. Spreading the limbs out wide captures the mood perfectly.

▶▶▶ **Example of a happy expression**

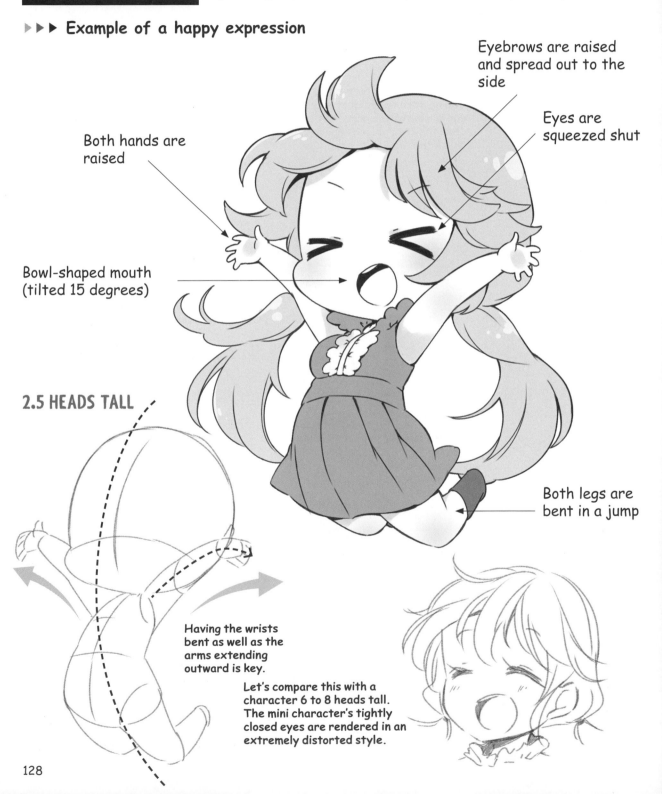

Eyebrows are raised and spread out to the side

Eyes are squeezed shut

Both hands are raised

Bowl-shaped mouth (tilted 15 degrees)

2.5 HEADS TALL

Both legs are bent in a jump

Having the wrists bent as well as the arms extending outward is key.

Let's compare this with a character 6 to 8 heads tall. The mini character's tightly closed eyes are rendered in an extremely distorted style.

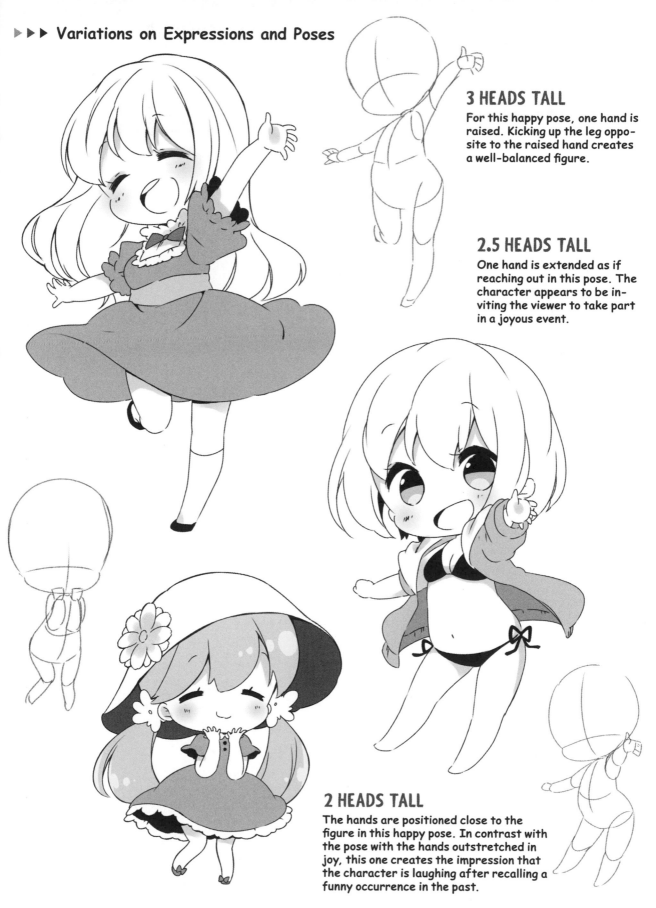

▶▶▶ **Variations on Expressions and Poses**

3 HEADS TALL

For this happy pose, one hand is raised. Kicking up the leg opposite to the raised hand creates a well-balanced figure.

2.5 HEADS TALL

One hand is extended as if reaching out in this pose. The character appears to be inviting the viewer to take part in a joyous event.

2 HEADS TALL

The hands are positioned close to the figure in this happy pose. In contrast with the pose with the hands outstretched in joy, this one creates the impression that the character is laughing after recalling a funny occurrence in the past.

▶▶▶ Different Expressions for Each Head-to-Body Ratio

Even when creating the same expression, the position of the features needs to be altered depending on the ratio. Make sure to carefully compare the relationship between the facial outline, the eyes and the shape of the mouth.

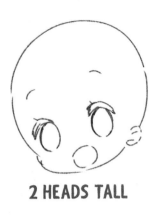

2 HEADS TALL

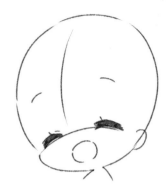

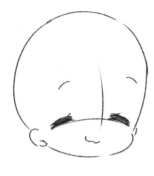

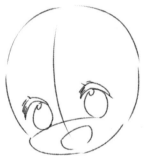

2.5 HEADS TALL

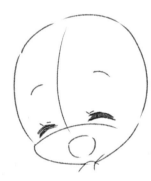

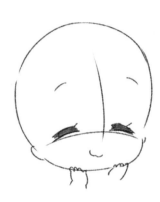

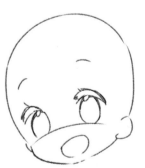

3 HEADS TALL

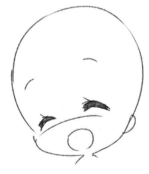

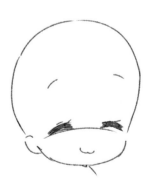

When it comes to capturing and expressing emotion, slight top are expressions for figures two and three heads tall. Slight differences in position significantly alter the impression created.

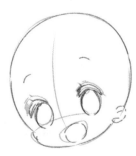

2.5 HEADS TALL + 2 HEADS TALL

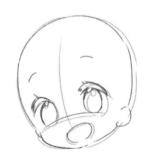

2.5 HEADS TALL + 3 HEADS TALL

▶▶▶ Key Points for an Energetic, Joyous Pose

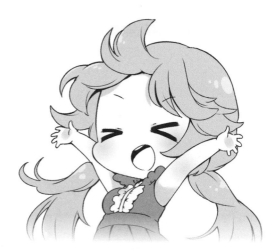

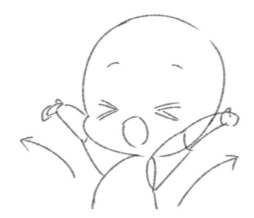

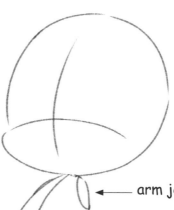

1. Below the head, draw the median line on the surface of the body. The torso is arched in this pose, so make it a smooth curve.

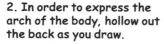

hollow it out

2. In order to express the arch of the body, hollow out the back as you draw.

arm joint

3. Block-in the arm joints. From this angle, the joint of the left arm is clearly visible but the right-arm joint can hardly be seen.

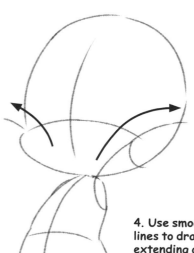

4. Use smooth, curved lines to draw the arms extending out.

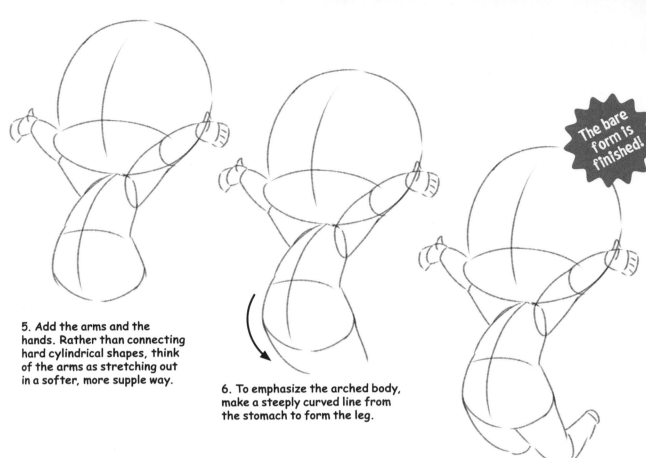

The bare form is finished!

5. Add the arms and the hands. Rather than connecting hard cylindrical shapes, think of the arms as stretching out in a softer, more supple way.

6. To emphasize the arched body, make a steeply curved line from the stomach to form the leg.

KEY POINTS FOR A POSE WHERE THE CHARACTER'S ENJOYING A PRIVATE MOMENT OF HAPPINESS

Here, the character's quietly laughing with happiness with her hand covering her mouth. The fingers of characters 2 heads tall are small, so think of them as beans next to the hands as you draw.

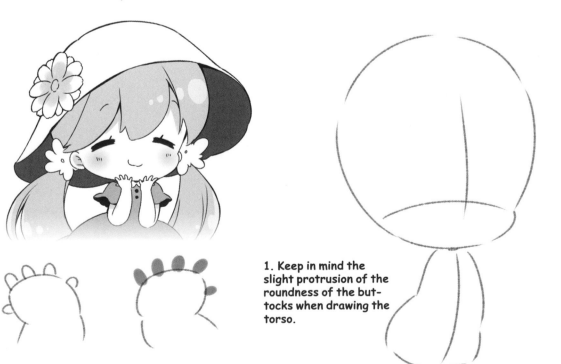

1. Keep in mind the slight protrusion of the roundness of the but- tocks when drawing the torso.

132

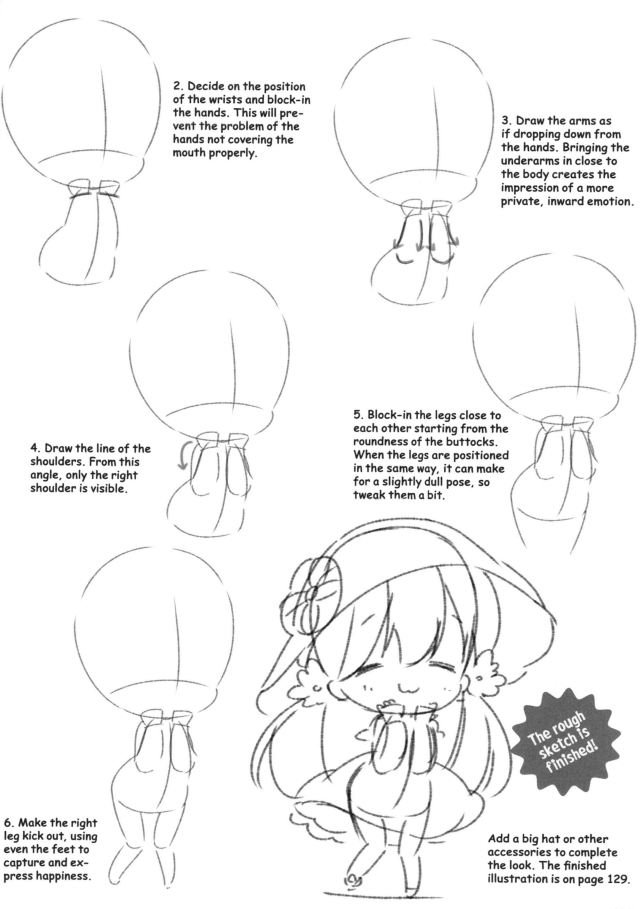

2. Decide on the position of the wrists and block-in the hands. This will prevent the problem of the hands not covering the mouth properly.

3. Draw the arms as if dropping down from the hands. Bringing the underarms in close to the body creates the impression of a more private, inward emotion.

4. Draw the line of the shoulders. From this angle, only the right shoulder is visible.

5. Block-in the legs close to each other starting from the roundness of the buttocks. When the legs are positioned in the same way, it can make for a slightly dull pose, so tweak them a bit.

6. Make the right leg kick out, using even the feet to capture and express happiness.

The rough sketch is finished!

Add a big hat or other accessories to complete the look. The finished illustration is on page 129.

CREATING ANGRY EXPRESSIONS

When chibi characters get angry, they can really really look incensed! From slight irritation to screaming at someone in rage, try out various expressions and degrees of anger.

Use a Solid Pose to Express Rage

A strong pose—such as with the feet firmly planted and standing drawn up to full height—creates the sense of being genuinely enraged. If the pose is the same as the stance used to express happiness, the character won't appear to be too angry. So the trick is to incorporate a relaxed element.

▶▶▶ **Example of an Angry Expression**

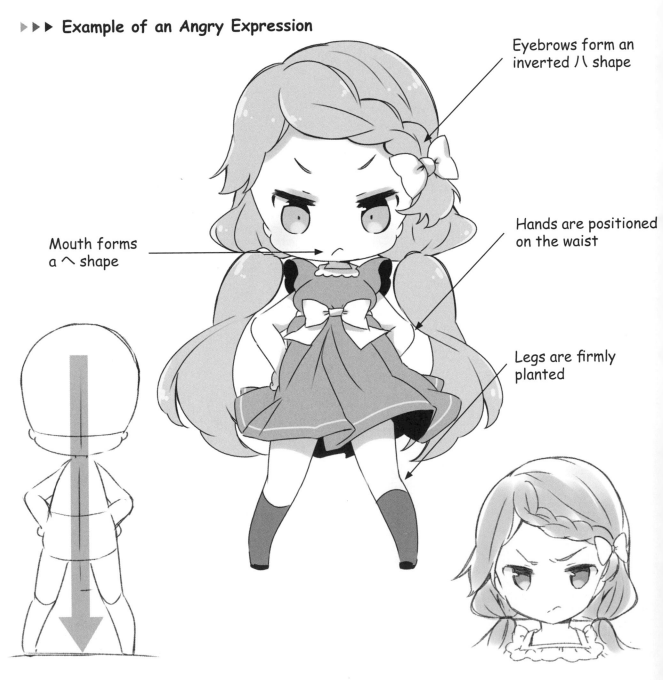

Eyebrows form an inverted ハ shape

Mouth forms a へ shape

Hands are positioned on the waist

Legs are firmly planted

134

▶▶▶ Variations on Expressions and Poses

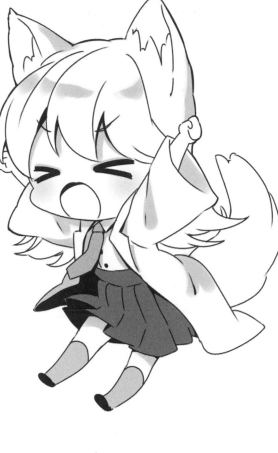

2.5 HEADS TALL

The arms wave above the head in frustration in this pose. Even though the arms are raised, the legs aren't extending as they would be for a happy pose, so the appearance of anger is created.

3 HEADS TALL

This is a pose of quiet rage. The arms are crossed and the legs are right next to each other, rather than planted firmly apart. The center of gravity, however, is stable so a look of extreme anger is created.

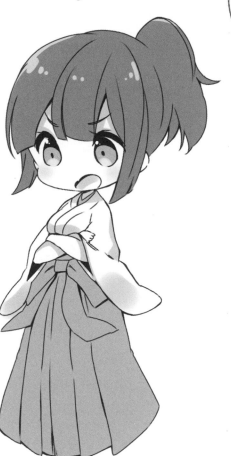

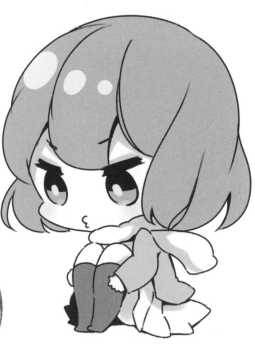

2 HEADS TALL

This pose depicts a character angrily sulking. As she's hunched and huddled, it looks like it will be difficult to improve her mood.

▶▶▶ Drawing Expressions Differently for Each Head-to-Body Ratio

Particularly obvious changes appear in the facial outline and in the degree of distortion applied to the eyes.

2 HEADS TALL

2.5 HEADS TALL

3 HEADS TALL

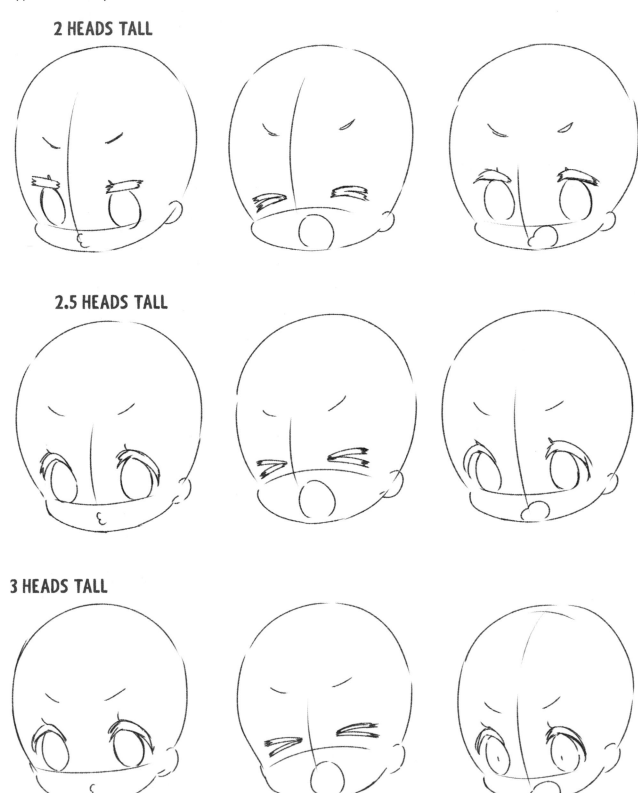

▶▶▶ Key Points for an Angry Pose with Folded Arms

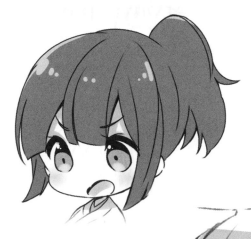

When a chibi character has folded arms, a trapezoid shape is formed from the shoulders to the arms. This is a distinguishing feature lacking in a character with realistically drawn proportions.

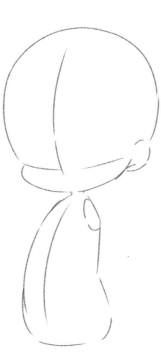

1. Draw the head and mark in the median line on the surface of the body to indicate the body's center. When angry, the body is unlikely to hunch over, so use a curved line to create a slight arch.

2. Add in the shape of the body, picturing a slightly curved tube as you draw. Check the joint for the left arm.

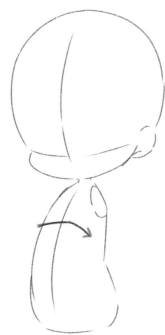

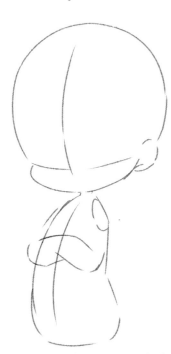

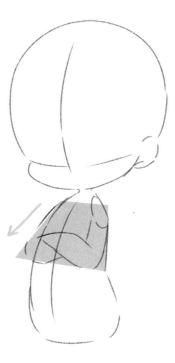

3. Block-in the lower arm. It rests close to the chest with the wrist bent.

4. Draw the lower arm with the other arm crossed over the top. Don't draw the ends of the hands at this stage.

5. Confirm that the shoulders to the arms create a trapezoid shape.

137

CREATING SAD EXPRESSIONS

Being hurt from a painful occurrence, experiencing heartbreak: when expressing sadness, use not only tears but the gestures that accompany the painful thoughts to really capture and drive home the emotion.

Use Gestures Directed Inward to Express Sadness

Rather than the outward exuberance of joy, sadness should be more self-contained in your chibi characters, using inwardly directed emotions.

▶▶▶ **Example of a Drawing Capturing Sadness**

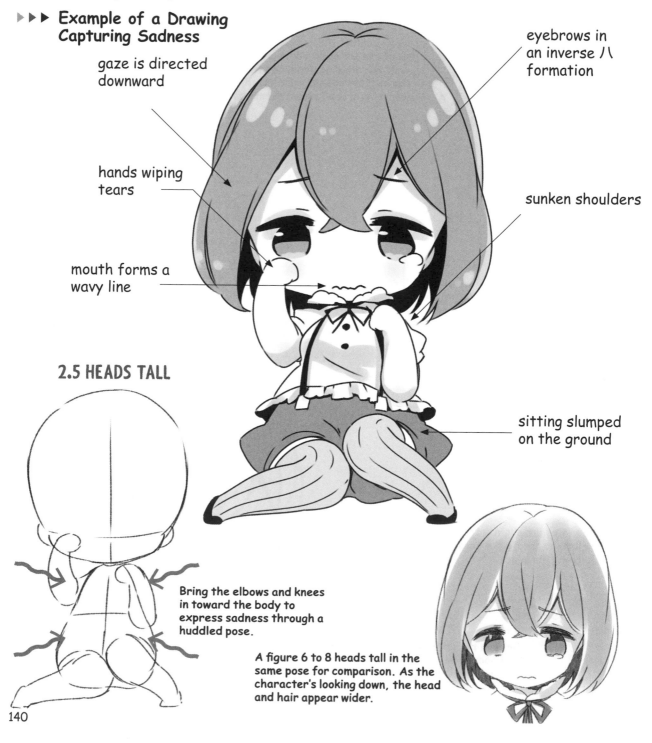

gaze is directed downward

eyebrows in an inverse /\ formation

hands wiping tears

sunken shoulders

mouth forms a wavy line

2.5 HEADS TALL

sitting slumped on the ground

Bring the elbows and knees in toward the body to express sadness through a huddled pose.

A figure 6 to 8 heads tall in the same pose for comparison. As the character's looking down, the head and hair appear wider.

▶▶▶ Variations on Expressions and Poses

2.5 HEADS TALL

A pensive face veiled in melancholy. The pose with the buttocks slightly protruding as the character turns around is sad, but charming at the same time.

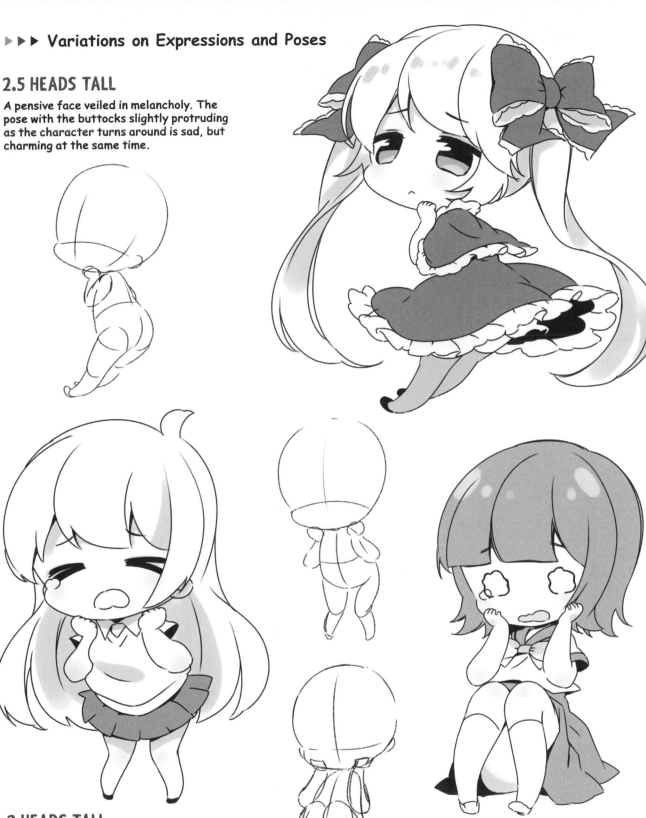

2 HEADS TALL

The character looks ready to cry out in anguish. The slight forward inclination of the body makes for the impression of the character telling someone about her sad feelings.

3 HEADS TALL

The eyes appear about to overflow with tears. The pigeon-toed pose is also a key element.

Drawing Expressions Differently for Each Head-to-Body Ratio

2 HEADS TALL

2.5 HEADS TALL

3 HEADS TALL

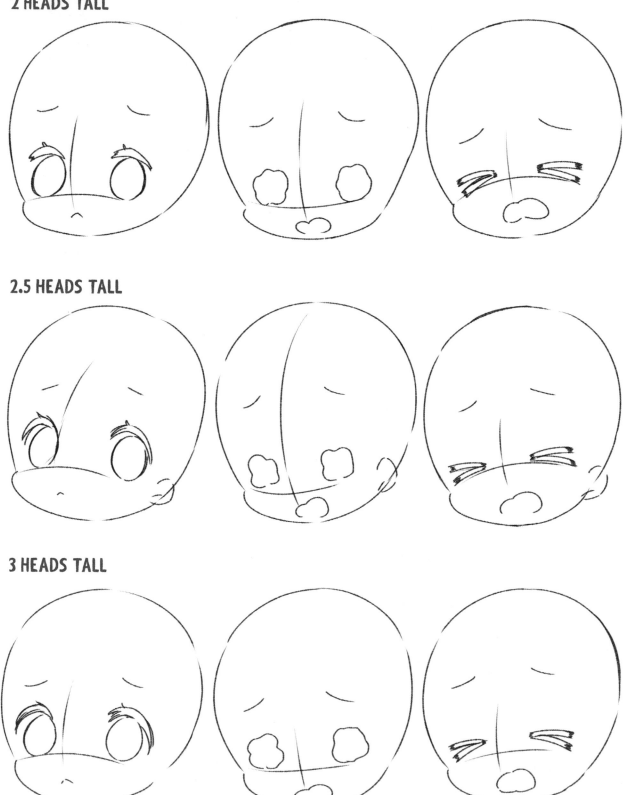

▶▶▶ Key Pose Points for a Character Hunched and Crying

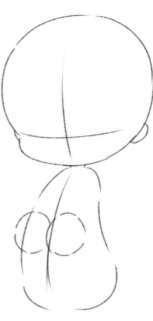

When drawing a huddled-up figure, start by blocking-in the gathered knees to make drawing easier.

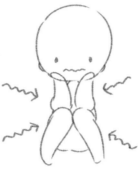

1. In this example, the figure is 3 heads tall. In order to express gloomy emotions, draw the face tilting slightly downward.

2. Block-in the body and decide on the position of the knees. As the knees are drawn in close to each other, make two connected circles that will form the kneecaps.

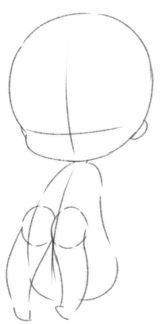

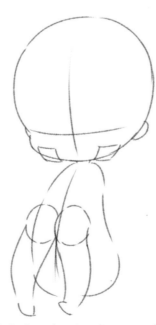

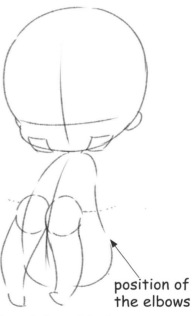

position of the elbows

3. Use the circles that form the position of the knees as a starting point and extend the legs down, drawing them so they curve slightly inward.

4. Before drawing the arms, decide where the hands will be positioned. Use squares to block-in the hands that are supporting the cheeks in sadness.

5. Draw in the waist using a curved line, and use this as the position of the elbows in order to draw in the arms.

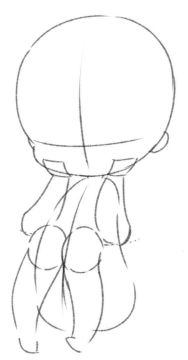

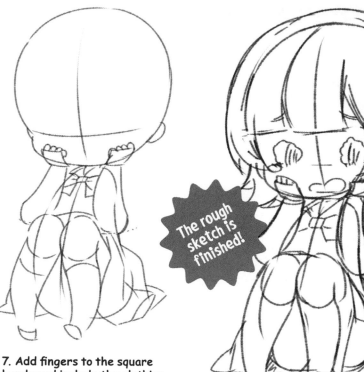

The rough sketch is finished!

6. Use a /\ shape to sketch in the arms, remembering to keep the upper arms close to the body for a huddled, drawn-in look.

7. Add fingers to the square hands and include the clothing.

8. Add the facial expression and hair. The combination of eyebrows in a /\ formation and the distorted eyes makes for a slightly comical expression of sadness. The finished illustration is on page 141.

▶ ▶ ▶ **Key Points for a Pose Where the Character's Sharing Her Sadness**

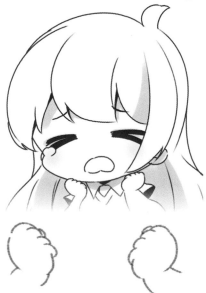

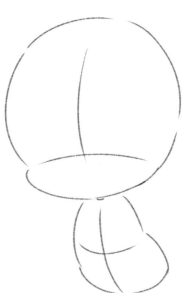

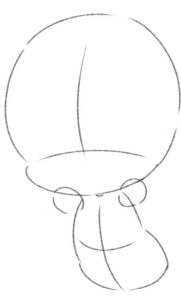

Here, the figure leans slightly forward, telling someone her problems. Drawing in the fingers rather than omitting them brings out the look of the hands clenched tightly into fists.

1. As the buttocks stick out slightly in this pose, the torso needs to protrude a bit.

2. Decide on the position of the hands before drawing the arms. Use circles to block-in the fists.

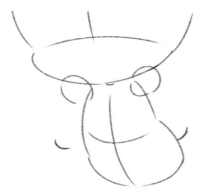 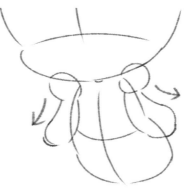 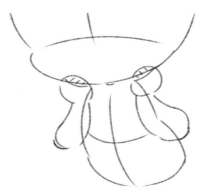

3. Decide on the position of the elbows. As the arms extend slightly in front of the body in this pose, the elbows are positioned not at the waist but a little bit lower.

4. Draw the arms, forming a ハ shape. The underarms remain close to the body.

5. Divide the blocking-in of the hands to form fingers.

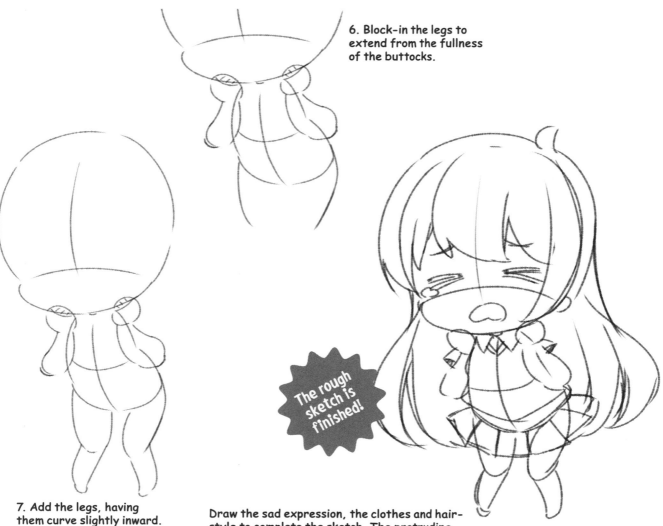

6. Block-in the legs to extend from the fullness of the buttocks.

7. Add the legs, having them curve slightly inward.

The rough sketch is finished!

Draw the sad expression, the clothes and hairstyle to complete the sketch. The protruding buttocks make for an illustration that clearly conveys the character relaying her sadness. The finished illustration is on page 141.

CREATING AWKWARD AND EMBARRASSED EXPRESSIONS

Blushing after being complimented, feeling awkward in an outfit, not being able to look someone directly in the eye. Try drawing pathetically cute expressions of self-consciousness and embarrassment.

Express Embarrassment Through Gestures

Feelings of awkward embarrassment reveal themselves in averted eyes and attempts to hide or conceal the face. Depict complicated emotions—such as embarrassed surprise or awkwardness from feeling troubled—with a nervous pose and facial expression.

▶ ▶ ▶ **Example of a Drawing Conveying Awkwardness**

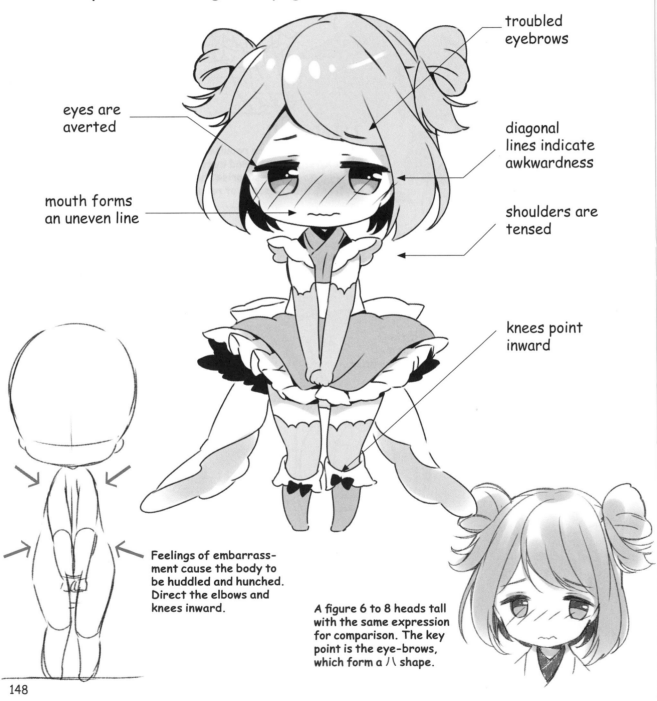

eyes are averted

mouth forms an uneven line

troubled eyebrows

diagonal lines indicate awkwardness

shoulders are tensed

knees point inward

Feelings of embarrassment cause the body to be huddled and hunched. Direct the elbows and knees inward.

A figure 6 to 8 heads tall with the same expression for comparison. The key point is the eye-brows, which form a / \ shape.

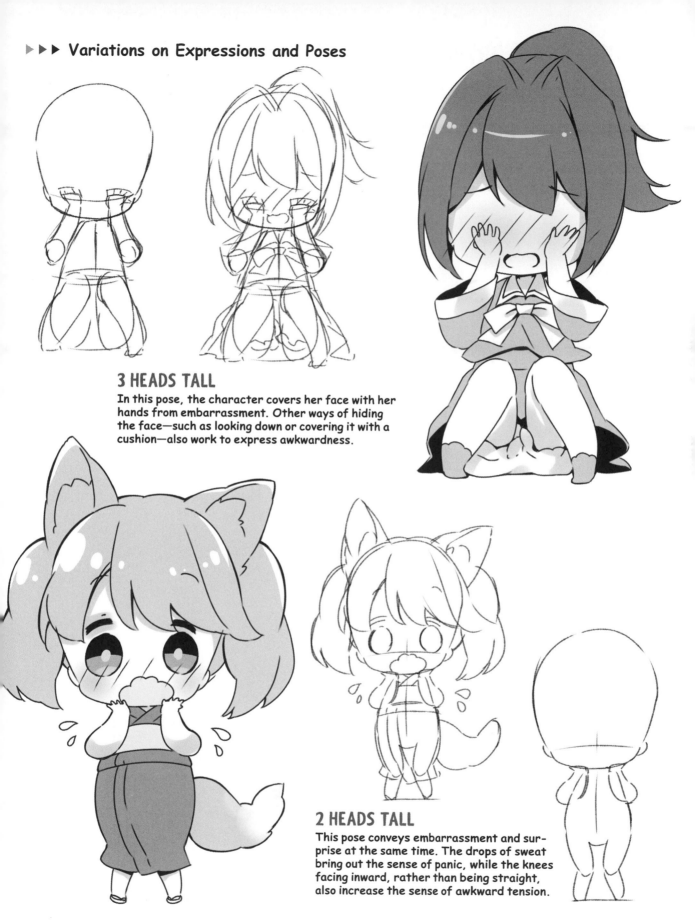

3 HEADS TALL

In this pose, the character covers her face with her hands from embarrassment. Other ways of hiding the face—such as looking down or covering it with a cushion—also work to express awkwardness.

2 HEADS TALL

This pose conveys embarrassment and surprise at the same time. The drops of sweat bring out the sense of panic, while the knees facing inward, rather than being straight, also increase the sense of awkward tension.

REFINE YOUR DRAWING TO IMPROVE IT

Beyond learning how to effectively convey your characters' emotions through facial expressions and poses, tweaks and refinements will allow you to create illustrations that really shine, whether as standalone drawings or part of an ongoing story of your own creation.

Alter the Silhouette Altering the form created by the outline of a person or object significantly changes a drawing's appearance.

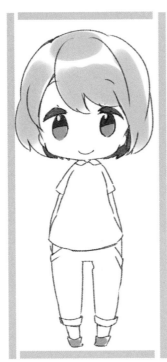

A pose where the character is simply standing there is a little dull . . .

. . . so making the silhouette into a triangle shape creates a more complex, compelling impression.

Having the character holding a large object is a good way of altering the silhouette too.

Using the skirt to form a triangle silhouette is one idea. Even though the character's standing in exactly the same way, she appears more charming.

Giving the character voluminous hair also works.

Use Surrounding Circles and Squares for a Cohesive Look

Sometimes having your chibi creation express emotion creates poses that don't quite come together properly. Remedy this by surrounding the character with circles and/or squares to add another visual dimension and level of refinement to your drawing.

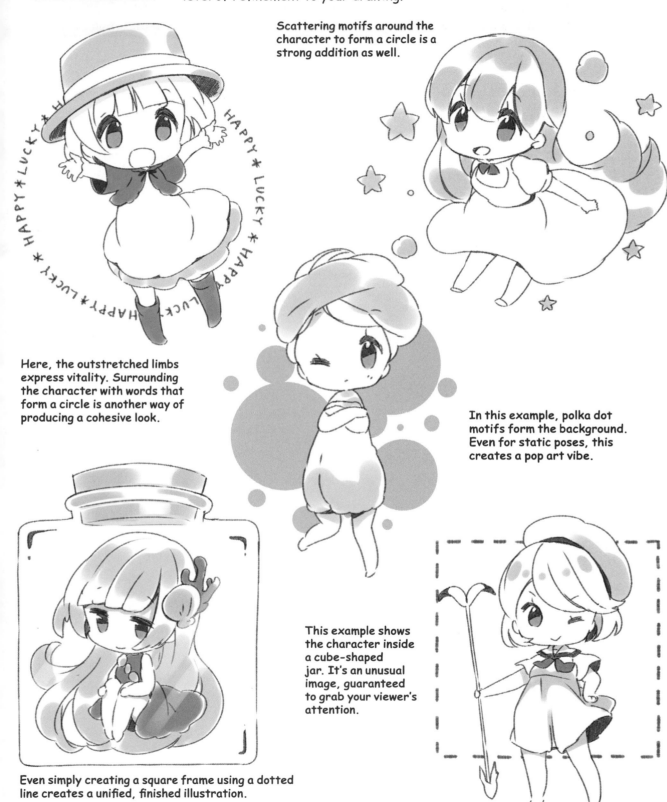

Scattering motifs around the character to form a circle is a strong addition as well.

Here, the outstretched limbs express vitality. Surrounding the character with words that form a circle is another way of producing a cohesive look.

In this example, polka dot motifs form the background. Even for static poses, this creates a pop art vibe.

This example shows the character inside a cube-shaped jar. It's an unusual image, guaranteed to grab your viewer's attention.

Even simply creating a square frame using a dotted line creates a unified, finished illustration.

USING MANGA SYMBOLS

Apart from using facial expressions and poses to express a character's emotion, it's also possible to incorporate symbols commonly used in manga. Adding symbols and graphics that everyone recognizes allows your characters to express all kinds of emotions.

HAPPINESS/POSITIVE EMOTIONS

Symbols for a sprightly, active air.

Heart shapes evoke amorous, warm feelings.

The expression for having noticed or realized something.

A sense of sparkling or radiance.

The look of talking cheerfully.

ANGER/NEGATIVE EMOTIONS

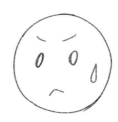

Veins popping out on the forehead are the standard way of depicting this mood.

Beads of sweat create a sense of panic.

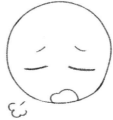

Attempting to keep frustration in check.

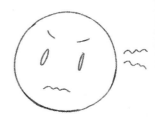

A sense of regret when something hasn't gone as planned.

Vertical lines on the forehead indicate turning pale.

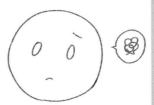

The expression of a sigh escaping.

OTHER EXPRESSIONS

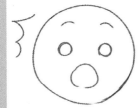

Surprise at something unexpected.

Diagonal lines on the face indicate embarrassment or awkwardness.

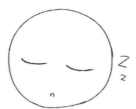

Zs indicate sleep.

This symbol indicates lethargy or listlessness.

Inside the Artist's Studio

6

Here's a rare opportunity to directly view the tricks and pitfalls of chibi creation. Let's peer over the artists' shoulders for a step-by-step look at how to build an effective chibi character from the first stroke to the last.
 Now pick up that pen and let's draw!

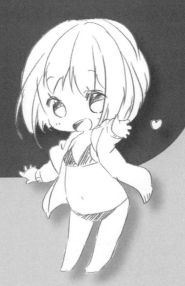

DRAWING A CHARACTER 2.5 HEADS TALL: BATHING SUIT

First, let's try drawing a figure 2.5 heads tall, which is the standard head-to-body ratio for a chibi character. Here, we're drawing a happy girl in a bathing suit.

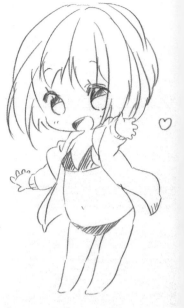

Point 1: The line of the body is visible when wearing a bathing suit

When your character's wearing a bathing suit, you can't take shortcuts by covering it up with clothing. Before adding the bathing suit, it's important to draw the bare form properly as this lays the foundation for the figure.

Point 2: Arm extended forward

The left arm's extended forward, creating extreme foreshortening. Draw the palm of the hand first and fill in the arm after.

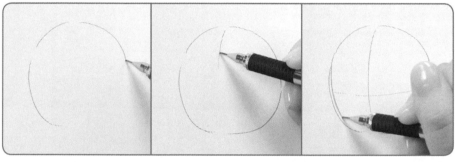

Draw a circle and add a line down the very center of the face.

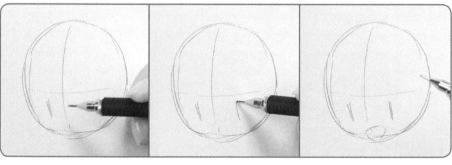

Block-in the eyes just beneath the halfway point of the face. The face is slightly tilted, so draw the eyes on an angle also.

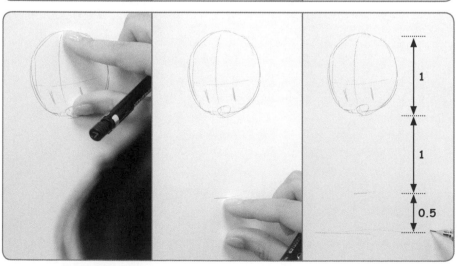

Measure one-and-a-half head heights with your finger and draw a horizontal line in to form the ground.

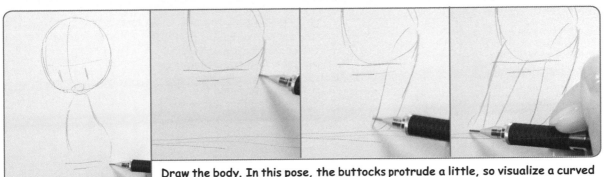

Draw the body. In this pose, the buttocks protrude a little, so visualize a curved tube as you draw. Draw the legs extending smoothly from the buttocks down.

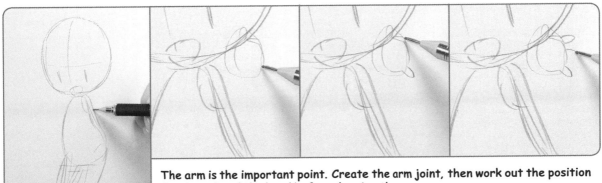

The arm is the important point. Create the arm joint, then work out the position for the palm of the hand before drawing the arm.

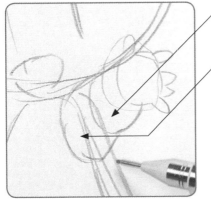

forearm

upper arm

The bare form is finished!

Draw the arm; it'll appear extremely short. Objects in the background appear even shorter, so the trick is to make the forearm slightly longer than the upper arm.

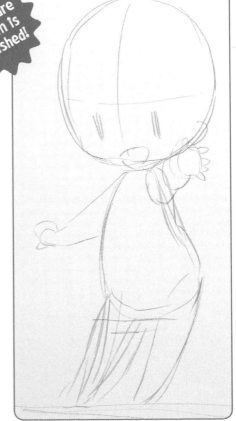

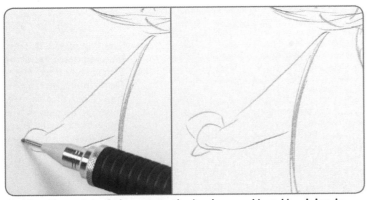

Making the wrist of the arm in the background bend back lends expression to the pose. Adjust the overall figure to complete the bare form.

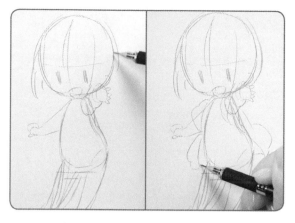

Draw the hair and clothing. Don't make the hoodie that the character is wearing over the bathing suit too close-fitting as having it swinging out around the figure adds a dynamic sense of movement to the drawing.

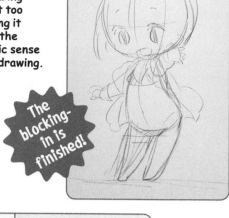

The blocking-in is finished!

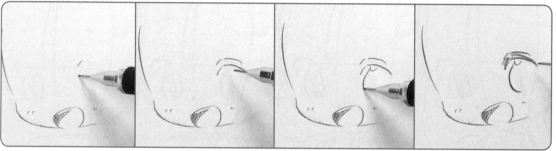

Draw up until here, then place fresh paper over the blocking-in to draw in the face and facial expression. Draw the eyes starting from the inner corner of the upper eyelid. Rather than simply tracing the rough drawing, draw with the aim of creating a new facial expression.

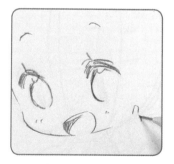 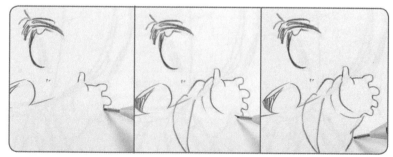

Once the expression is done, next draw the hand at the front. The wide-spread fingers match the character's personality and good nature.

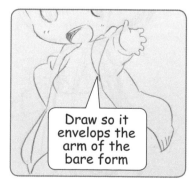

Draw so it envelops the arm of the bare form

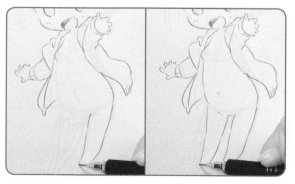

The line of the hoodie hanging down from the arm is very important for bringing out dimension. Draw the hoodie to envelop the arm in the rough sketch and mark in the shape for the lower body also.

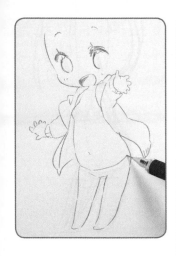

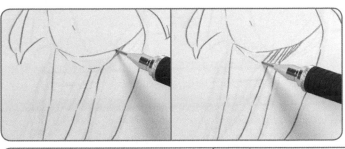

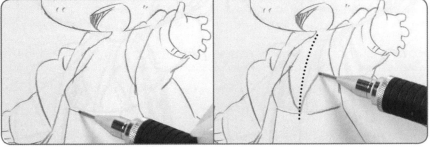

In contrast to the hoodie, make sure the bikini bottoms fit close to the body.

Even though this is a chibi character, clearly indicate the chest area. Make sure the fabric of the bikini is symmetrically positioned on either side of the median line (the line running down the center of the body's surface).

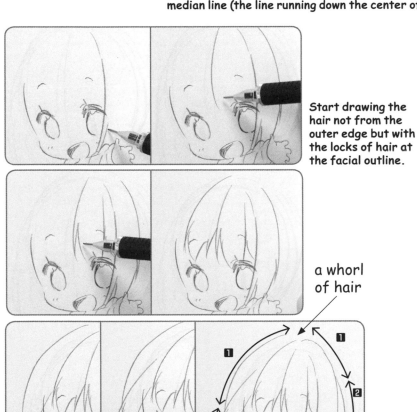

Start drawing the hair not from the outer edge but with the locks of hair at the facial outline.

a whorl
of hair

Indicate the flow of the hair starting at the whorl. 1 is the section of the hair that follows the shape of the head; 2 is the section that flows out away from the head. By dividing the hair into two sections, it's possible to give it an airy flow.

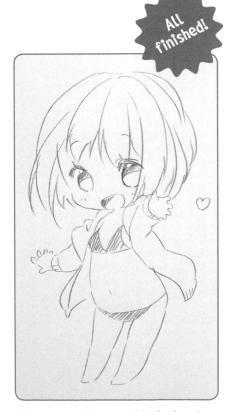

ALL finished!

The energetic pose with the hand extended, the softly flowing hoodie, the gently fluttering hair: the combination of these elements makes for an illustration that clearly conveys the character's cheerful charm.

DRAWING A CHARACTER 2.5 HEADS TALL: TURNING AROUND

Chibi characters don't seem like they would move much, but they can be posed in all kinds of ways depending on how they're drawn. Here, let's try drawing a pose in which the character's body is twisted to look behind her.

Point 1. Indicate turning around using the movement in the neck

A realistically drawn character turns around by moving the shoulders and neck, but a chibi character's torso can't twist much. To compensate, the neck rotates in order to indicate the turned and twisted position.

Point 2. Take care with the balance of the head and torso

Rather than having the figure turning around while standing straight, creating a pose such as with the buttocks protruding leads to a more appealing result. On the other hand, this makes it harder to get the balance of the head and body right, so check the balance at the blocking-in and bare-form stages before drawing in the finer, more detailed sections.

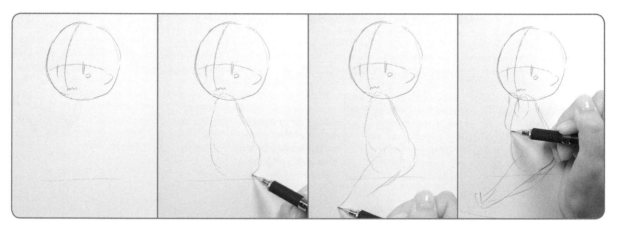

Draw the head and block-in the body beneath it. The turning action will be expressed through the neck, so the body barely twists.

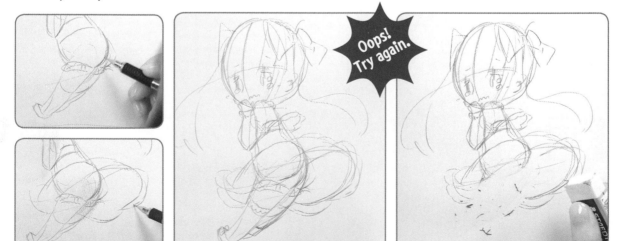

Draw the underwear and mark in the shape of the skirt. But the balance doesn't seem right somehow. The body and legs are long, making for a drawn-out look.

Erase that area and correct the balance of the body.

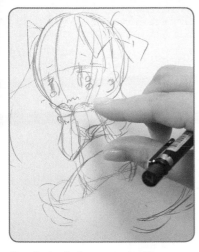

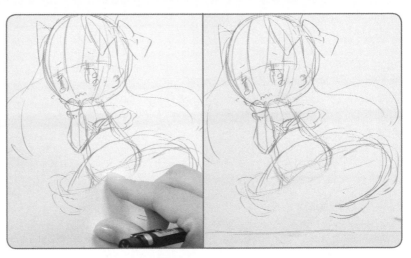

Check the balance again. For a figure 2.5 heads tall, the body length should be shorter than 1 head height.

Check the length from the crotch to the feet. It should be about three-fifths the head height. Draw the ground in where the feet will be planted, on a diagonal angle to the body.

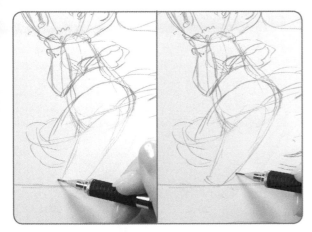

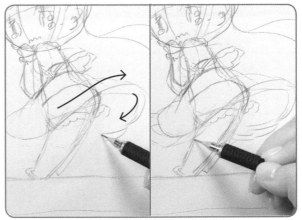

The bottom is sticking out, so mark in the body and legs to form a > shape.

Use a smooth, flowing curved line to draw the airy, swinging hem of the skirt and lightly add in the lace.

The blocking-in is finished!

The compact body and legs make for a cohesive appearance. Compare the drawing with the one on the right, which shows the mistakes. The balance is off and the character looks like she'll topple over at any moment. In the corrected version, the figure is balanced and has properly rounded buttocks.

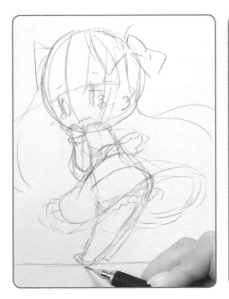

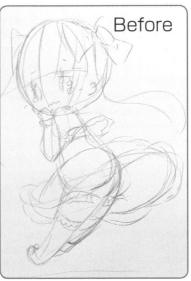

Before

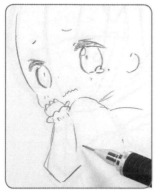

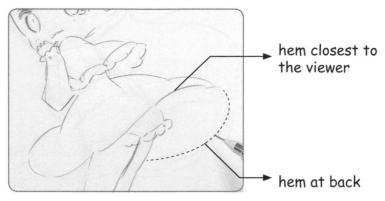

hem closest to the viewer

hem at back

Place fresh paper over the drawing to continue working. When drawing the body parts, draw the hand, arm and shoulder in front first.

Draw the section of the hem closest to the viewer before drawing the rest of the skirt.

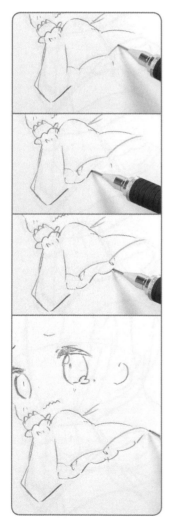

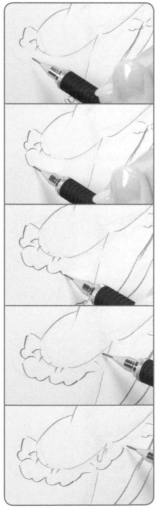

Take care to neatly connect the frill to the section of skirt that's flared.

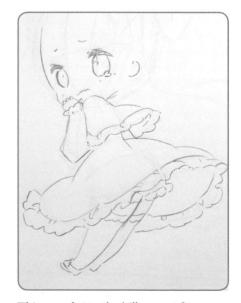

Draw the cape covering the shoulders. Mark in the shape so the fabric sits slightly away from the body and draw in the frill.

For the skirt frill, draw the wavy lines for the outer edges before marking in the wrinkles on the inner edges.

This completes the billowy outfit.

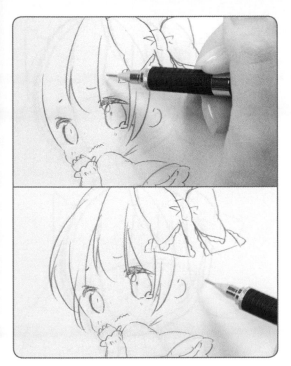

Draw the face and hair, starting with the bow that's in the foreground, then adding the flow of the bangs. Make the hair flow slightly to the left, in keeping with the > shape of the pose.

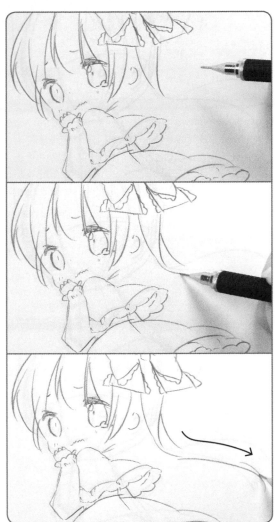

Add movement to the pigtail. Sweep the pen outward in broad strokes so the pigtail fans out part of the way down.

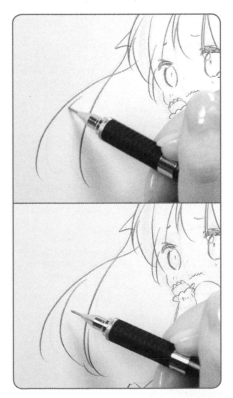

Divide the hair at the end of the opposite pigtail into a fine and a thick part to heighten the level of expression. Add tears to the eyes to complete the picture of a young girl full of chibi charm.

ALL finished!

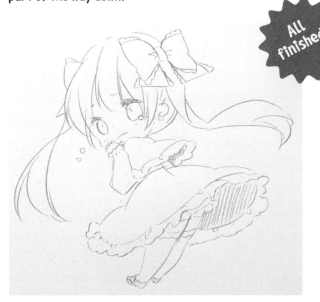

DRAWING A CHARACTER 2 HEADS TALL: STANDING IN A ROBE

The degree of distortion is strongest in figures with this head-to-body ratio. Let's start with drawing a standing figure. Here, animal ears and a robe add distinction and individuality.

Point 1. Balancing parts that express individuality

The animal ears express individuality so make them big and bold. At the same time, characters 2 heads tall have small bodies, so with only the ears, the head appears heavy. Add a big tail too to create balance.

Point 2. A chibi-style robe

Apply distortion to the robe so that it suits the physique of a figure 2 heads tall. Make the sash sit high on the body and draw the hem slightly flaring out to create a chibi-style garment that differs from the real thing.

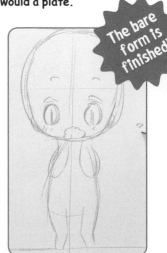

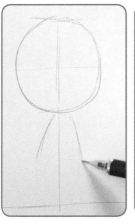
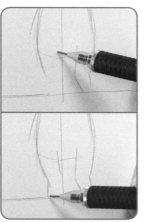
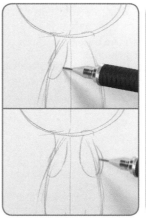
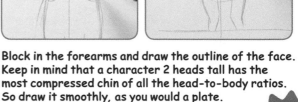

Draw a circle to block-in the head and make the line for the ground one head's worth below that. Mark in the upper body using a /\ shape and draw the crotch and legs.

Block in the forearms and draw the outline of the face. Keep in mind that a character 2 heads tall has the most compressed chin of all the head-to-body ratios. So draw it smoothly, as you would a plate.

The bare form is finished!

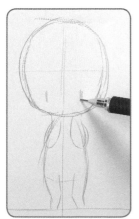
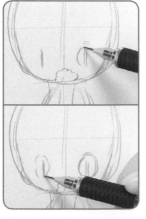
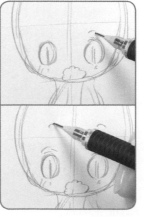
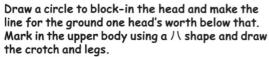

Determine the position of the eyes. Drawing the eyes slightly apart from the upper lids gives the eyes a surprised look. Make them a bit smaller to balance things out.

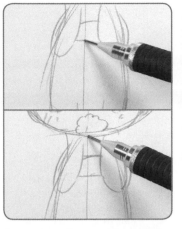

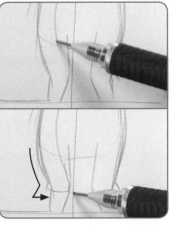

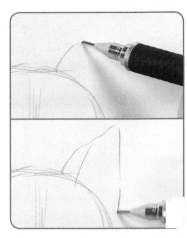

Draw the robe, positioning the sash much higher than for a realistically drawn character. Making the hem of the robe billow out emphasizes the roundness of the body.

The ears are the cutest feature so make them big (the ears are not calculated in the head-to-body ratio).

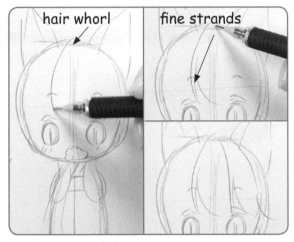

hair whorl fine strands

Draw the bangs extending from the whorl at the crown of the head. Divide them broadly into three pieces with slightly finer strands in between.

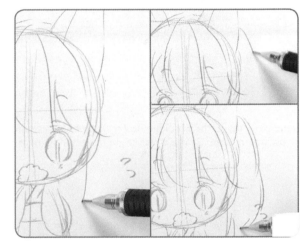

Make the pigtails rounded and fluffy. Decide on the shape of the outer edges before drawing in the ends of the hair.

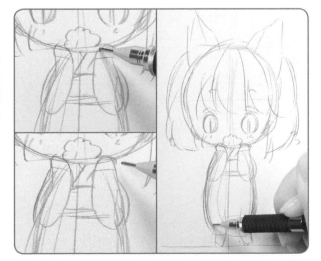

Have the ends of the hair slightly touch the cheeks. Adjust the line of the body to create a suggestion of chubbiness.

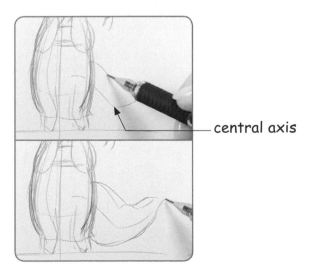

central axis

In order to create balance with the big ears, draw in a large tail. Mark in the central axis of the tail before drawing the outline.

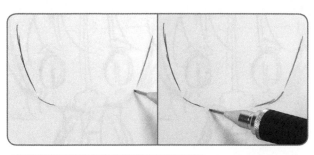

The blocking-in is finished!

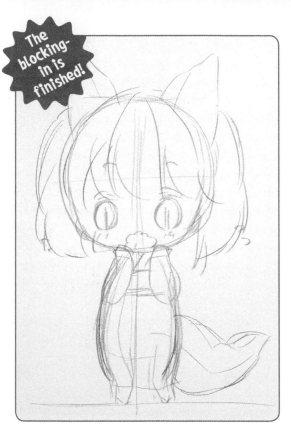

Determine the shape of the facial outline and draw the hands touching the cheeks. The loosely open mouth and red cheeks create an expression of happiness with a slightly different nuance to that of a full-blown smile.

This completes the blocking-in for the whole body. Place a fresh piece of paper over the drawing and look at the blocked-in figure underneath while filling in the details.

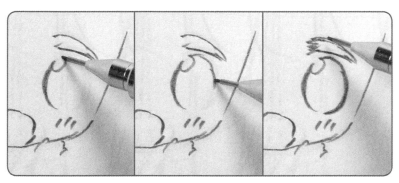

Draw the upper eyelids and then draw in the eyes. The eyelids are only very slightly curved. Think of them as being in a /\ shape with a small gap between them.

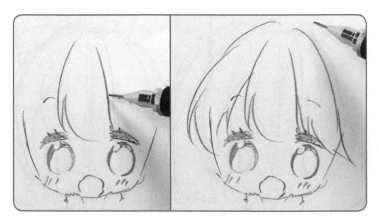

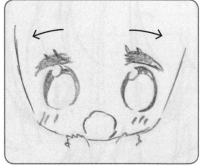

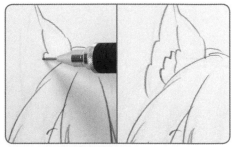

Use softly curved lines to create airy or feathery bangs. Add several curved lines one after the other to layer fluffy fur onto the ears.

164

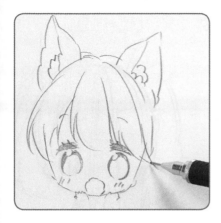

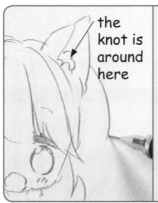

the knot is around here

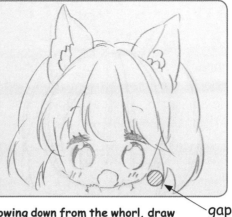

gap

Once you've drawn the hair flowing down from the whorl, draw in the pigtails that start from behind the knot in the ears. The key point is the gap between the cheeks and hair. The pieces of hair flutter out to add to the expression of surprise.

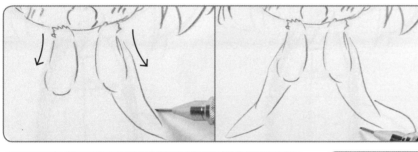

It's important that the arms arch slightly outward. Make the sleeves of the robe extend outward too for added expression.

ALL finished!

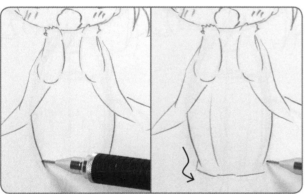

Draw the hem of the robe flaring out. This is an important element to include when creating chibi-style characters.

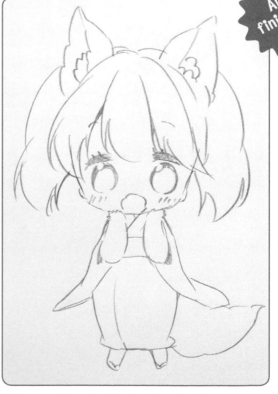

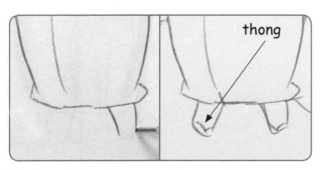

thong

The feet stick out from under the hem of the robe. As the character isn't wearing shoes, but straw sandals, draw in the thong section.

This completes the illustration of a character whose fluffy ears, tail and pigtails suit her very slightly surprised, awkward expression.

DRAWING A CHARACTER 2 HEADS TALL: A CROUCHED, HUDDLED POSE

As characters 2 heads tall have small bodies, it would seem difficult to create poses in which their bodies are curled up or hunched over. However, if the overlapping of the body and limbs is done correctly, you can draw these figures in poses where they're crouched and trying to make themselves small.

Point 1. Changes to the body when it's curled up

Rounding the body creates an equally rounded spine that brings the shoulders forward and makes the neck contract. Even for chibi characters whose necks aren't visible, the hunching of the shoulders can be expressed by bringing the head forward. So as you draw, think about how to depict the body's changes.

Point 2. Adjust the length of the limbs

For a character 2 heads tall, it would be difficult for it to grasp its knees, given the length of the limbs. Make the limbs a bit longer than they'd actually be, making sure they still look natural within the general degree of distortion applied.

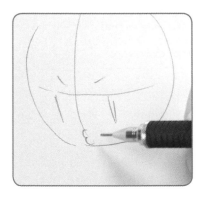

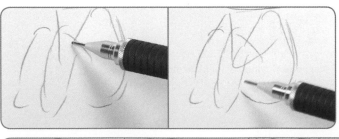

Block-in the head and draw the body beneath it at three-fifths the size of the head. To make the neck appear as if it's jutting forward, position the body slightly to the back of the head rather than directly below it.

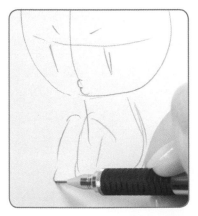

Determine the position of the knees and draw the legs extending from them. Usually, the legs of a figure 2 heads tall are only two-fifths the height of the head but for this pose, lengthen them so that they'll appear natural for even a distorted figure.

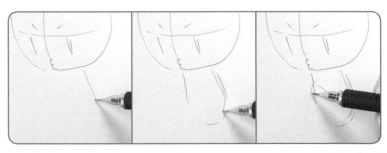

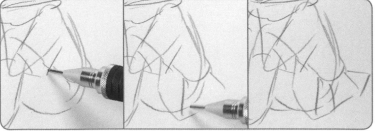

Draw the arms, which are shorter than the legs, and draw the skirt to match the curve of the thighs, flipping up at the back.

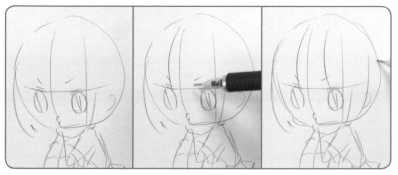 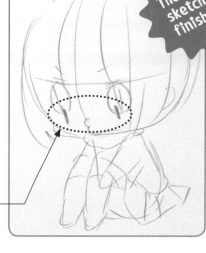

Roughly draw in the hair. At this point, looking at the face, it didn't look sulky enough, so the position of the eyes was adjusted so that they're cast down, emphasizing the pouting expression.

lower the eyes

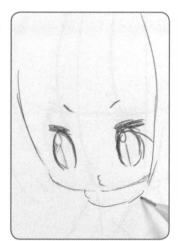 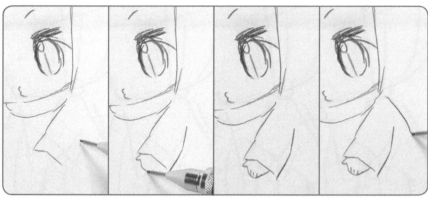

Place a fresh sheet of paper over the blocking-in and add the finer details. For the hands, mark in the overall shape and then include lines to divide them into fingers.

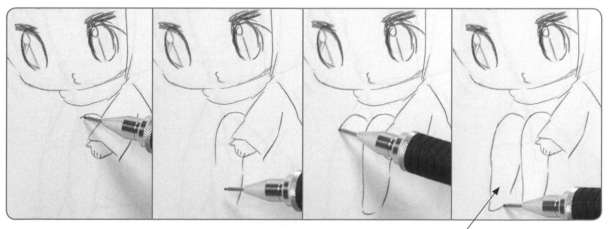

Draw the legs, starting with the one closest to the viewer. The round, smooth kneecaps are a key point in terms of cuteness. Don't place the legs right next to each other, but change the pose slightly to bring out expression.

legs in different positions

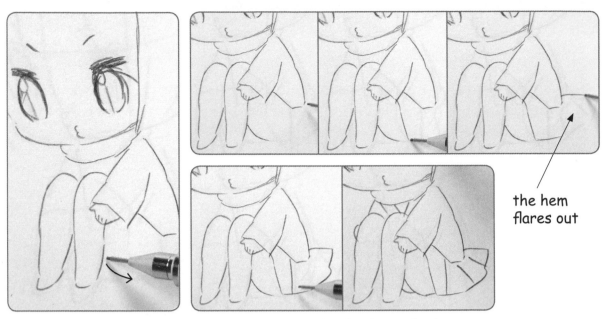

the hem
flares out

Draw the cute, chubby thighs and skirt covering them. Rather than having the character seated on it, drawing the hem flaring out makes the skirt look more realistic.

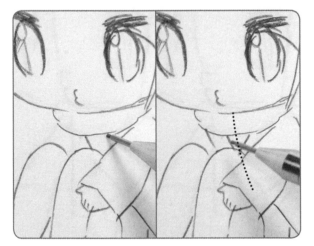

Draw the collar, working toward the median line of the rough sketch (the line that divides the surface of the body in half).

Draw the arm farthest away at the same angle as the arm closest to the viewer. Make sure to draw in the mound that indicates the hand holding the knee.

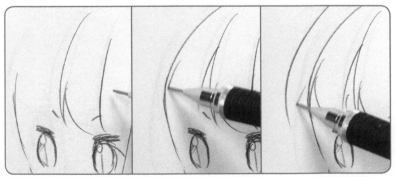

Draw the hair, taking into account the roundness of the head. As this character is 2 heads tall, thicker pieces of hair suit her best.

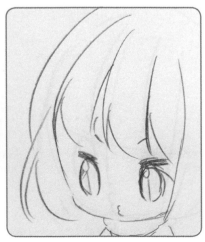

flow from the hair whorl

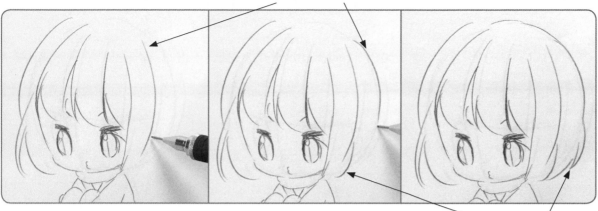

Draw the hair extending from the whorl and
the flow of the ends of the hair separately.

flow of the hair ends

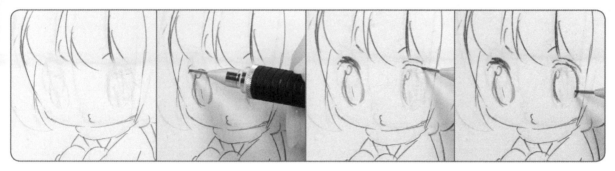

The expression seemed a bit cold so the eyes were corrected. The eyes are practically
the same shape, with the curved upper eyelids making them appear wide open.

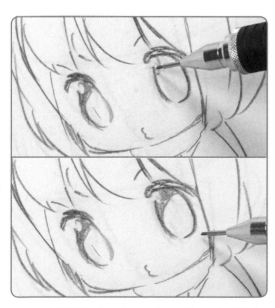

Draw highlights (sections where the light hits)
in the upper left of each eye and darken the
sections that are in shadow.

Changing the cold-looking eyes to ap-
pear alert and open yields a pose that's
appealing despite its sulkiness.

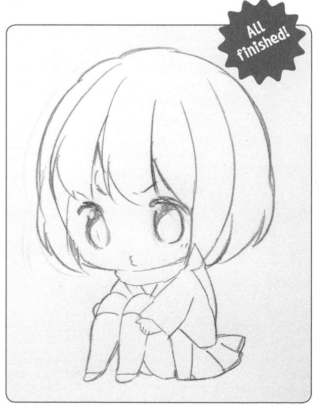

All finished!

169

DRAWING A CHARACTER 3 HEADS TALL: A VIVACIOUS POSE

Figures 3 heads tall have limbs that are long by chibi character standards. Take advantage of the freedoms that length provides to create powerful poses full of appeal.

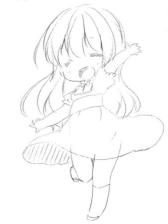

Point 1. Depicting raised hands

When chibi characters attempt to raise their arms, their big heads get in the way. In reality, it's not possible for them to raise their hands, but drawing them in a manga-like fashion yields a natural appearance.

Point 2. Posing the legs

One leg poised behind the other creates an energetic pose. However, drawing the legs as they would normally be positioned makes the character look as if she'll tumble over, so shift the weight-bearing foot to line up with the center of the body for a balanced appearance.

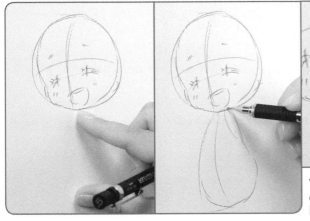
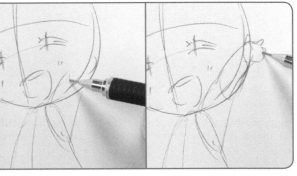

The bodies of figures 3 heads tall are the same size as one head. Use your fingers to measure the size of the head and draw the body. Draw circles for the arm joints and add in the raised arms overlapping the face.

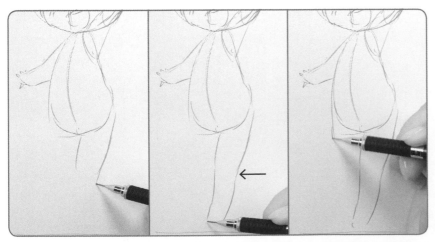
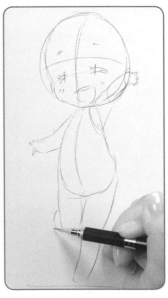

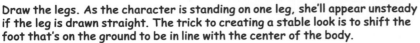

Draw the legs. As the character is standing on one leg, she'll appear unsteady if the leg is drawn straight. The trick to creating a stable look is to shift the foot that's on the ground to be in line with the center of the body.

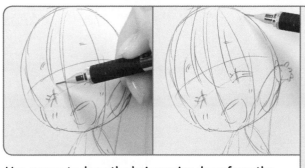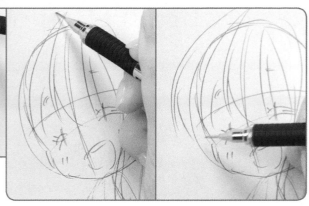

Use curves to draw the hair coming down from the whorl. At this stage, don't worry too much about forming pieces and strands; just draw the hair in roughly.

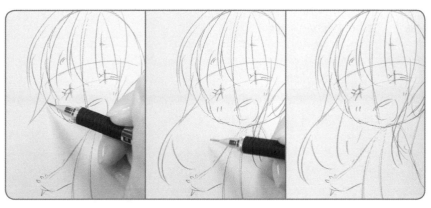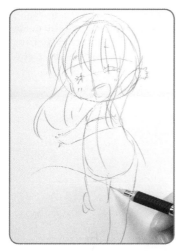

Draw the hair flying out behind to match the vibrancy of the pose. Draw the locks of hair spreading out to accentuate movement.

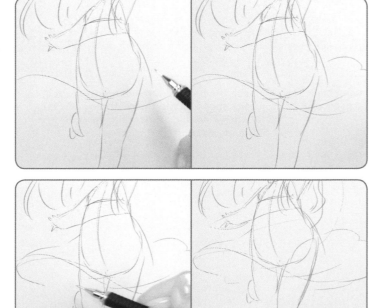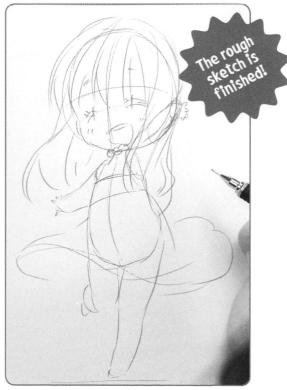

The rough sketch is finished!

Make the skirt flare for an even more energetic look. Make one side of the skirt flip up in front of the body. Don't forget to connect it to the back.

Place fresh paper over the drawing and draw in the face. The closed eyes would be at the position of the lower eyelids if the character were realistically drawn, but for a chibi character, placing them in the centers of the eyes strikes the right balance.

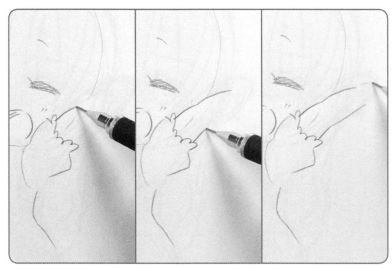

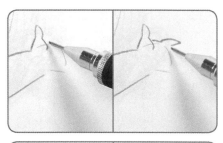

Where the arm extends from the frill of the sleeve, don't make it straight, but remember to include the elbow joint as you draw.w

For the palm of the hand, first mark in the shape of the thumb, then draw the remaining fingers, working toward the joint of the little finger.

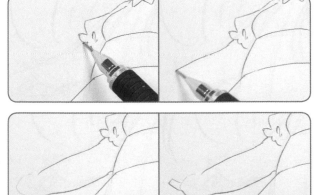

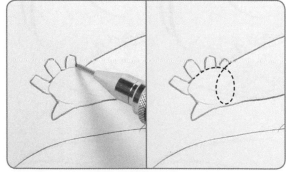

For the hand farthest away, it's the back of the hand that'll be visible. Think of this section as being slightly concealed by the wrist in order to draw it.

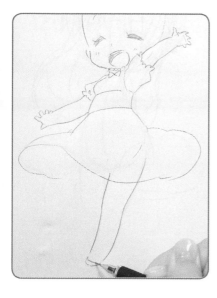

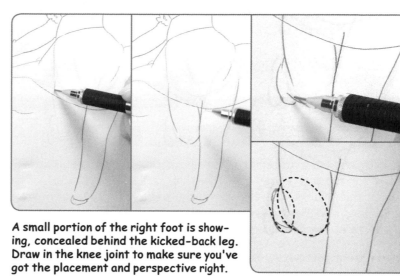

A small portion of the right foot is showing, concealed behind the kicked-back leg. Draw in the knee joint to make sure you've got the placement and perspective right.

Fill in the details on the bodice, adding the frilly edge.

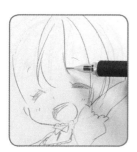

Fill in the hair, starting with the bangs, then the strands extending behind and beside each of the outstretched arms.

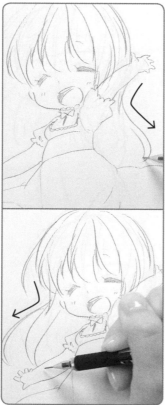

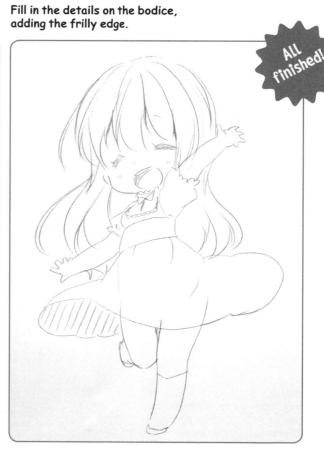

All finished!

DRAWING A CHARACTER 3 HEADS TALL: A KNEELING POSE

It's difficult to grasp the form of the legs in a seated pose, but have a go at drawing a sitting figure 3 heads tall. Here, the character exudes a hint of boredom as she kneels with her legs bent to the side, flat on the floor.

Point 1. Understanding the positioning of the legs

Given that chibi characters that are 3 heads tall have short legs, it's difficult for them to kneel with their legs out to either side like this. When it comes to drawing this pose, the best you can do is to make sure the legs don't look excessively odd or awkwardly positioned. Start with the leg in the foreground and then add the one in the background.

Point 2. Posture for the upper body

When seated with the knees grasped, the back is rounded, but for this pose draw the back with a bit of an arch for an appealing sense of innocence.

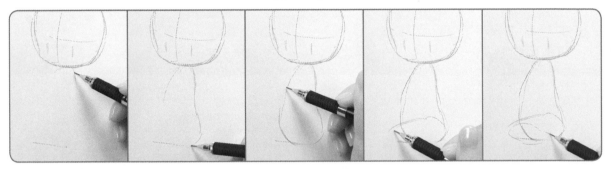

Draw the line for the ground one head height below the actual head. Draw the body and draw the thighs directly touching the ground. Draw the legs from the knees down over the top of the thighs. The trick to getting this look right is to disregard the thickness of the thighs and shins.

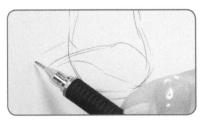

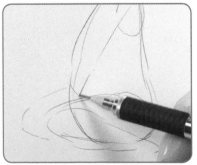

To convey the manner in which the character is sitting, show the leg in the background. Draw the knee-caps so that the legs match up.

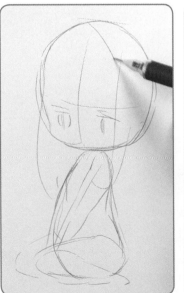
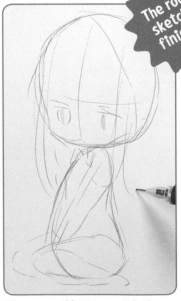

Draw the hood of the sweatshirt with a curved line to match the roundness of the head. Roughly mark in the shape of the hair.

The rough sketch is finished!

174

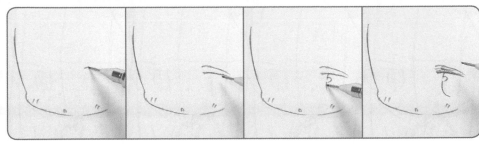

Place a fresh sheet of paper over the blocking-in and proceed with the drawing working from the facial outline to the eyes.

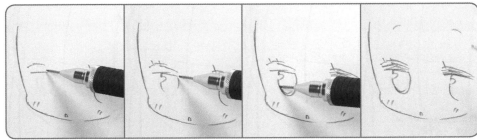

The slightly bad mood that seems to be indicated by the direct gaze is achieved by making the upper eyelids nearly straight. The angle of the upper eyelashes can subtly alter the expression.

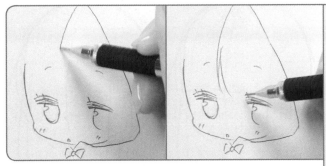

First, draw the peak of the hood, then add in the hair. Mark in the hair starting with the bangs, then bring the side section out from the hood. Make it just touch the eyes and create a soft look by drawing it in an undulating line.

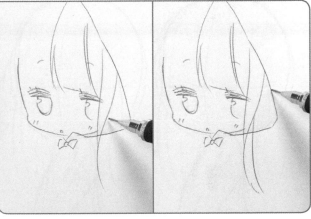

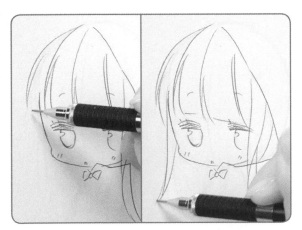

Draw the hair in the background differently from the bangs. Here, it's meant to look soft, so have it fall straight down with a little movement in the ends.

Draw the glasses, which are one of the main features for this character. Make sure they don't get in the way of the eyes by not drawing the parts that cover them. The trick to doing this is to make them large and shift them down the nose slightly.

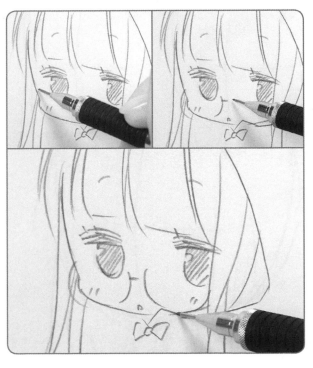

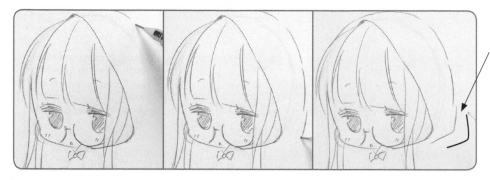

create a corner

Draw the outside of the hood to surround the head. Don't make it completely round, but rather create a corner at the bottom for a realistic look.

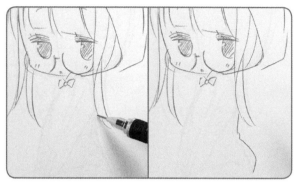

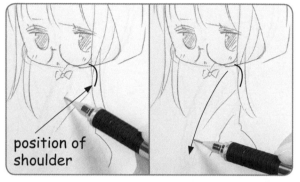

Draw the detailed parts of the body, starting with the arch of the back.

position of shoulder

The back is arched, so this means that rather than the shoulders moving inward, they're pulled slightly back. Draw from the shoulders to the arms, extending them down to the thighs.

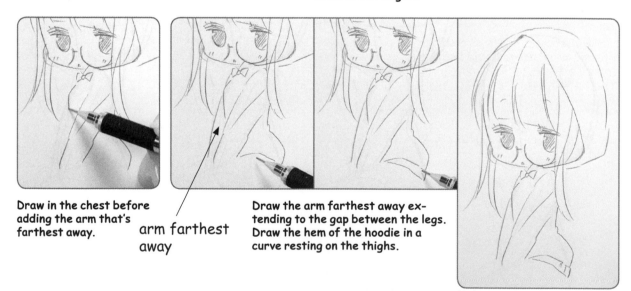

Draw in the chest before adding the arm that's farthest away.

arm farthest away

Draw the arm farthest away extending to the gap between the legs. Draw the hem of the hoodie in a curve resting on the thighs.

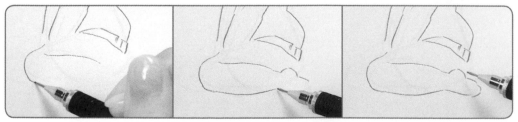

Draw the legs, starting with the shins of the leg closest to the viewer. Don't make it straight, but remember to narrow it at the ankle to create a chubby, cute leg.

176

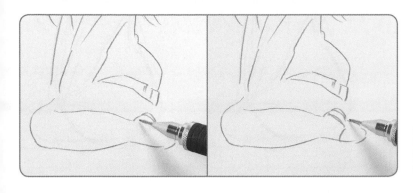

Add the details of the shoes to the feet. As this is for a figure 3 heads tall, make sure to draw in the soles properly.

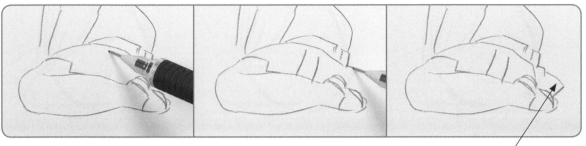

Keep in mind that the skirt is resting on the legs and so forms a curved shape. Spread out the wrinkled back section to make it look more like a skirt.

spread it out slightly

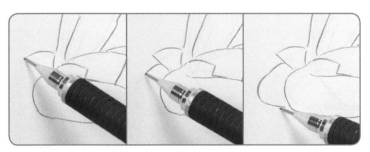

After drawing the skirt on the leg farthest away, add in the kneecaps so they're neatly aligned.

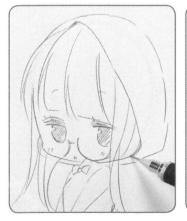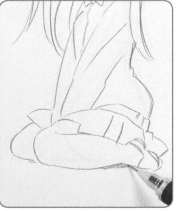

As there's a fair amount of hair, it might look more natural to have more of it coming out from the hood, so add more hair ends. Add shadow in the gaps of the hood and below the ankles to create dimension and complete the drawing.

All finished!

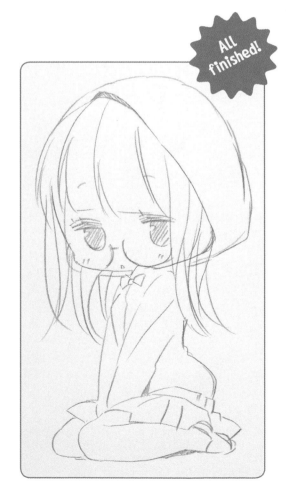

DRAWING FIGURES POSED AT DIFFICULT ANGLES

Once you're used to drawing chibi characters, try drawing them from difficult angles. Here, we'll look at drawing a character viewed from overhead and from below.

Drawing the Kneeling Pose from Overhead

Try drawing the kneeling character on page 174 from an overhead angle. The key points are rendering the head, body and the way the legs meet.

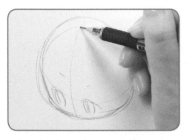

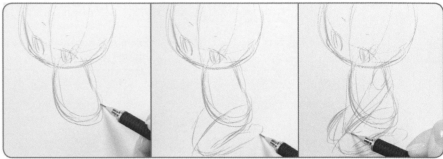

When looking down on the character, the head appears to be the largest and closest part of the body. The neck and shoulders are concealed by the head. The front of the thighs is clearly visible. Check these points as you block-in the figure.

The whorl of the hair is clearly visible and the eyes and mouth are concentrated in a lower position on the face. The hood appears to take up a lot of room. Mark in the shape of the hood covering the head and roughly draw in the hair to complete the blocking-in.

hair whorl

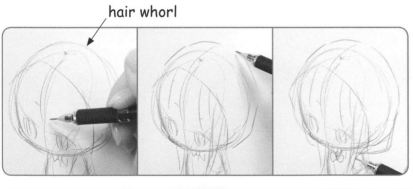

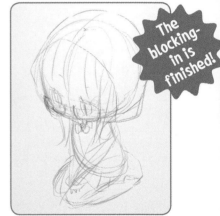

The blocking-in is finished!

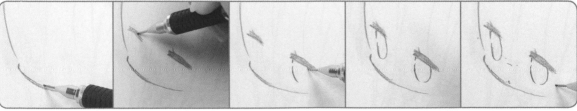

Place a fresh sheet of paper over the blocked-in figure. The eyes are not on the standard angle, but on a diagonal. Draw the upper eyelids for each eye first, setting them on a diagonal, and then draw in the eyes.

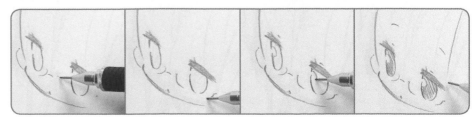

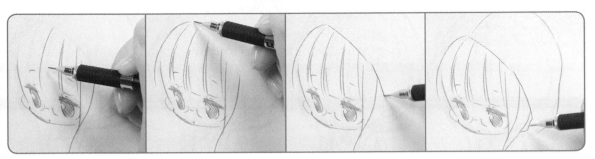

As the view is from above, the bangs also flow on a diagonal angle. Draw the fold line in the peak of the hood so it can be clearly seen.

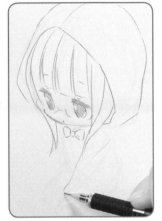

From this angle, the hand in the gap between the thighs isn't hidden but is visible. Add in both hands in front of the body.

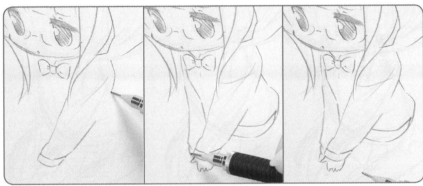

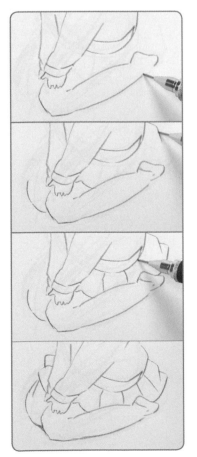

Draw the legs with the knee-caps close to each other and the pleats in the spread-out skirt to complete the drawing.

Compare this with a standard angle. Drawing the character from an overhead angle adds just the slightest impression of loneliness.

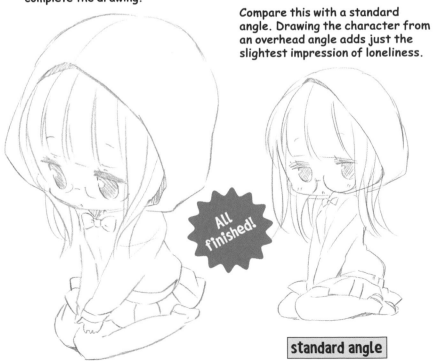

All finished!

standard angle

Drawing the Bathing Suit Pose from Below

Now try drawing the girl in the bathing suit on page 154 from an angle below the figure. Keep in mind that from this angle, the head appears farthest away.

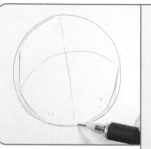

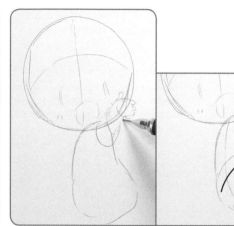

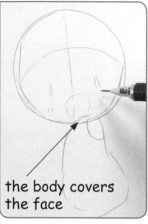

Draw the head and block-in the body. As the figure is being viewed from below, draw the body to slightly cover the face.

the body covers the face

The extended hand is the closest to the viewer. Make sure it blocks the face. The blocking-in for the waist section forms an arc.

The blocking-in is finished!

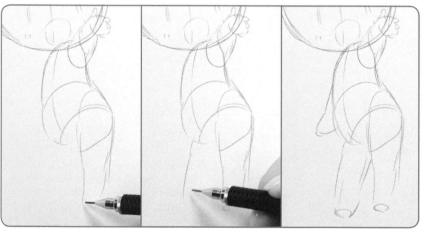

As the view is from below, the legs and feet appear closest and largest. Draw them as if looking up at two rounded cylinders and roughly draw in the expression and hair to complete the blocking-in.

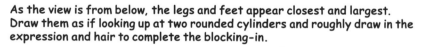

Place a fresh sheet of paper over the drawing and add the detailed parts of the body. Draw the hands starting with the thumbs and then the palms before adding the remaining fingers. Fill in the line of the outer garment to match the roundness of the arms.

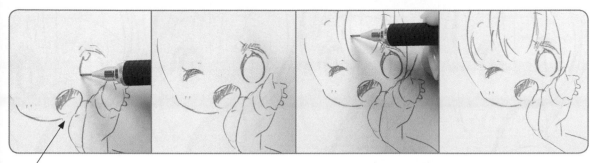

below the chin isn't visible

Draw the facial expression. From this angle, the area below the chin would usually be visible and there would be a gap between the mouth and the facial outline. But in this case, the character is posed looking down slightly, and the area below the chin can't be seen.

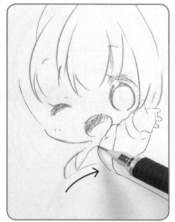

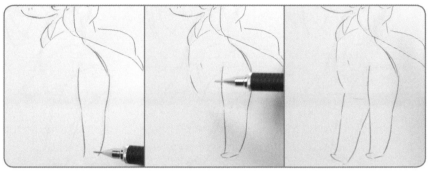

Using an arc to draw the line beneath the bikini top makes this angle look more realistic. Keep in mind as you draw that the lower belly and crotch sections are clearly visible from this angle.

The right hand is in the background, so appears smaller than the left hand, which is extended forward.

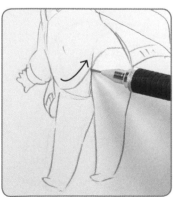

Draw in the bikini bottoms using an inverse arc in line with the swell of the belly.

The drawing of a cheerful character viewed from below is complete. The characteristics of this angle are particularly obvious in the bikini sections, so compare this picture with that of a standard angle.

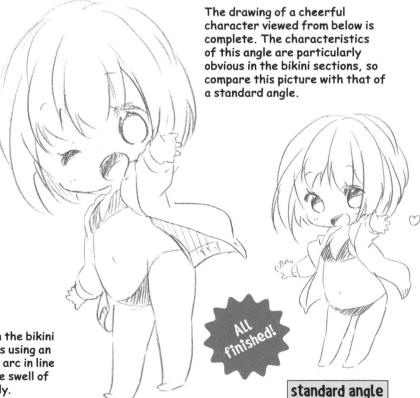

ALL finished!

standard angle

Conclusion

Thank you for picking up *A Beginner's Guide to Drawing Manga Chibi Girls!*

We've covered a lot of ground as you've learned how to draw the three main sizes of chibi characters—2, 2.5, and 3 heads tall—and how to distinguish between them. For chibi characters, the degree of distortion used for parts of the head and face and a body that's in balance with the rest are all important.

Summing up chibi characters isn't easy as there are so many types. In this book, we concentrated on chibi characters with a stereotypical charm and cuteness. We also touched on how to draw lines and used photos to document drawing characters using mechanical pencils. This information forms a reference for drawing not only chibi characters, so use it as you progress and expand your horizons as an artist and illustrator.

Anyone who has picked up this book is surely a fan of cute chibi characters. Now you can bring one of your very own to life on a completely blank sheet of paper. Simply pick up a pen and draw a line to get started. Even if you can't draw very well when starting out, you'll improve little by little with each attempt and you're sure to feel the joy of creating a mini character all on your own. Soon enough, you might become the chibi master, teaching others the secrets and techniques.

—Mosoko Miyatsuki

About the Illustrators

Mosoko Miyatsuki studied manga, anime and character design at Nihon Kogakuin College, and her work has included web manga series, game character design and illustrations for how-to books. Her publications include *My Older Brother Is My Rival, Fierce Fight! Smash Beat, Drawing Moe Characters: Basic Techniques* and *Drawing Moe Characters: Personalities and Emotions*. She currently works as a lecturer at Nihon Kogakuin College.

Tsubura Kadomaru mentors artists employed in the gaming and animation industries and is studying oil painting, with a focus on visual expression and the golden age of contemporary art, at Tokyo University of the Arts.

Good circles, good blocking-in and good bare forms: these are the hallmarks of successful chibi characters!

My co-author, Mosoko Miyatsuki, usually uses graphics software to draw on a personal computer, but I asked her to teach me various hand-drawn (or "analogue") tricks using a mechanical pencil and copy paper, such as how to draw lines and the steps she follows for drawing characters, starting with blocking-in. So pick up a pen and get going, being bold and free with your strokes and lines, as if you were tagging a wall with graffiti.

When drawing, it's often the case that you set out to draw a completed piece with no sketches or blocking-in. The paper typically ends up covered in lines that go nowhere. Drawing strong circles and effectively blocking-in your chibi parts and features may seem like the long way around, but it's a logical and effective method for capturing the image you want to draw. If you can combine the two techniques with strong bare forms, you should be able to draw a delightfully memorable character that expresses the uniqueness of your artistic vision!

The movements and expressions that seem cartoonish and exaggerated on a realistic character 6 heads tall look adorable and appealing on a mini character. With characters 2, 2.5, and 3 heads tall running all over its pages, this book of techniques overflows with the energy and vitality only chibi can bring.

This angel from a religious illustration has the look of a chibi character 1 head tall. I sketched it using Italian Renaissance painter Giovanni Bellini's "Madonna of the Red Angels" as a reference. In the actual painting, the cherubs are captured in red oil paint. Apparently, cherubs have a high status among angels and their wings and faces take many different forms.

—Tsubura Kadomaru

"Books to Span the East and West"

Tuttle Publishing was founded in 1832 in the small New England town of Rutland, Vermont [USA]. Our core values remain as strong today as they were then—to publish best-in-class books which bring people together one page at a time. In 1948, we established a publishing office in Japan—and Tuttle is now a leader in publishing English-language books about the arts, languages and cultures of Asia. The world has become a much smaller place today and Asia's economic and cultural influence has grown. Yet the need for meaningful dialogue and information about this diverse region has never been greater. Over the past seven decades, Tuttle has published thousands of books on subjects ranging from martial arts and paper crafts to language learning and literature—and our talented authors, illustrators, designers and photographers have won many prestigious awards. We welcome you to explore the wealth of information available on Asia at **www.tuttlepublishing.com**.

Published by Tuttle Publishing, an imprint of Periplus Editions (HK) Ltd.

www.tuttlepublishing.com

MINI CHARACTER NO EGAKIWAKE HONWAKA 2.5/2/3—TOUSHIN HEN
Copyright © Mosoko Miyatsuki, Tsubura Kadomaru / HOBBY JAPAN
All rights reserved.
English translation rights arranged with Hobby Japan Co., Ltd.
through Japan UNI Agency, Inc., Tokyo

Library of Congress Cataloging-in-Publication Data in process
ISBN 978-4-8053-1613-9

English Translation © 2021 Periplus Editions (HK) Ltd.

24 23 22
10 9 8 7 6 5 4 3 2
Printed in Singapore 2202TP

Distributed by

North America, Latin America & Europe
Tuttle Publishing
364 Innovation Drive
North Clarendon, VT 05759-9436 U.S.A.
Tel: 1 (802) 773-8930;
Fax: 1 (802) 773-6993
info@tuttlepublishing.com
www.tuttlepublishing.com

Japan
Tuttle Publishing
Yaekari Building, 3rd Floor
5-4-12 Osaki
Shinagawa-ku
Tokyo 141 0032
Tel: (81) 3 5437-0171;
Fax: (81) 3 5437-0755
sales@tuttle.co.jp
www.tuttle.co.jp

Asia Pacific
Berkeley Books Pte. Ltd.
3 Kallang Sector, #04-01
Singapore 349278
Tel: (65) 67412178;
Fax: (65) 67412179
inquiries@periplus.com.sg
www.tuttlepublishing.com